www.lauragivens-artist

Copyright 2016 Laura Givens

All rights reserved

See the world through cats' eyes.

Long before mirrors we saw reflections of ourselves by watching cats. Those reflections may have been a funhouse distortion of our vanities, joys and dignities, but we recognize them instantly, and ascribe a kinship between the two species on a deep, primal level.

Cats and dogs have lived with humans throughout our history on this planet. While dogs are companions and helpers, they rarely rise to an equal footing with their masters. Cats, on the other hand, don't even acknowledge the word "master" exists. We humans are just there to provide sustenance and nurturing while we marvel at their antics.

Cats provide us with untold hours of entertainment simply by their existence and such is the mandate of this coloring book. May you enjoy the time you spend bringing to life these elaborate pages with all the playful and wondrous embellishment your love of the subject will bring them.

Why Art Nouveau? First conceived a century ago, it is a style that celebrates a playful, passionate immersion into its intricacies. It provides the repetition, detail and flow that best personify what a good adult coloring book should be.

Coloring books for adults have become a big deal. They are psychologically calming and can facilitate a meditative state. They provide a focus to tap into our creative potential and allow us to tune out the crazy world that constantly assaults us. Coloring books are non-judgmental, there is no right or wrong way to color them. It's true, coloring books can be very therapeutic… YUP! But, let us not forget, coloring is fun. . So put on your fuzzy slippers, pour a glass of wine and color yourself into the world of the cat.

It's cheaper than psychoanalysis.

Laura Givens

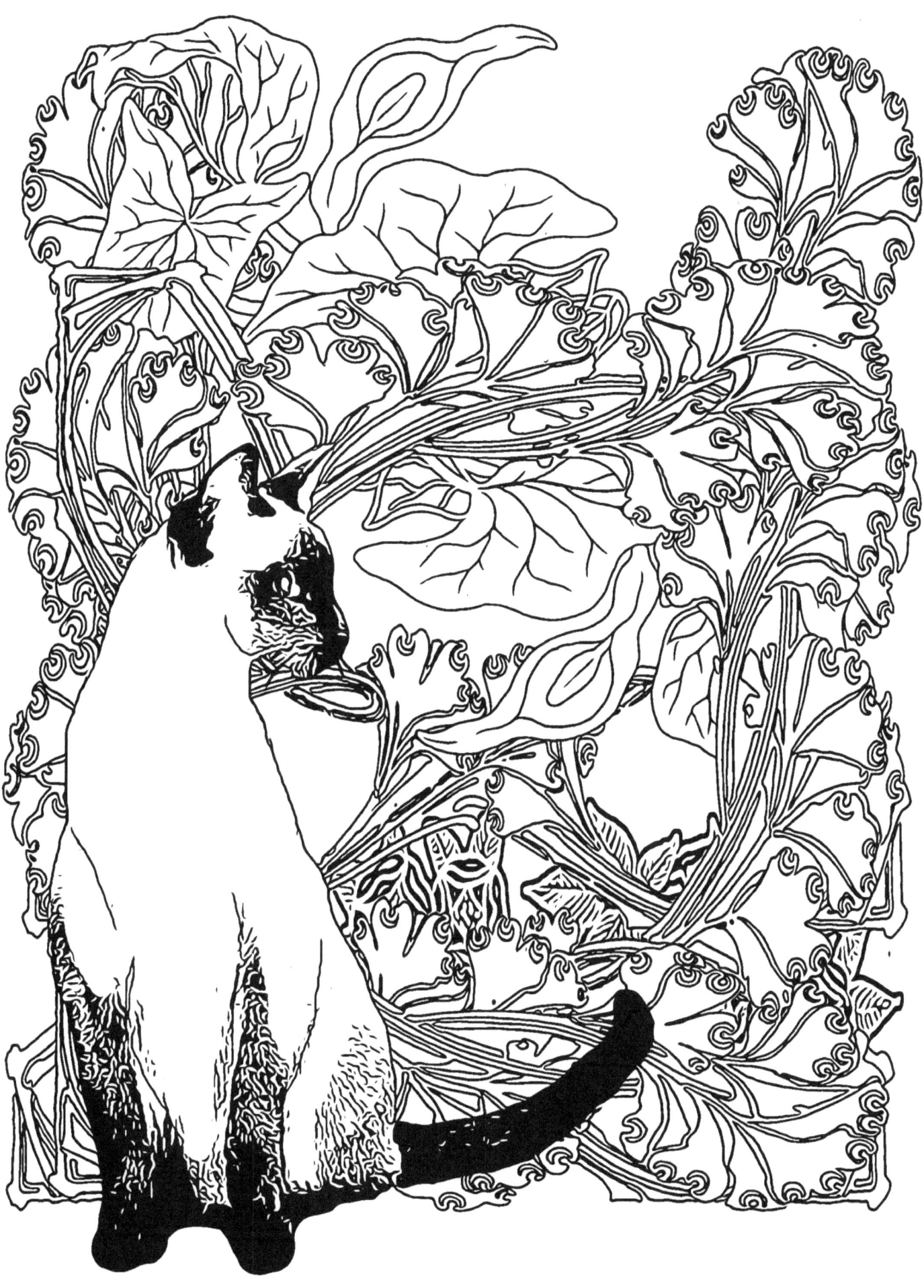

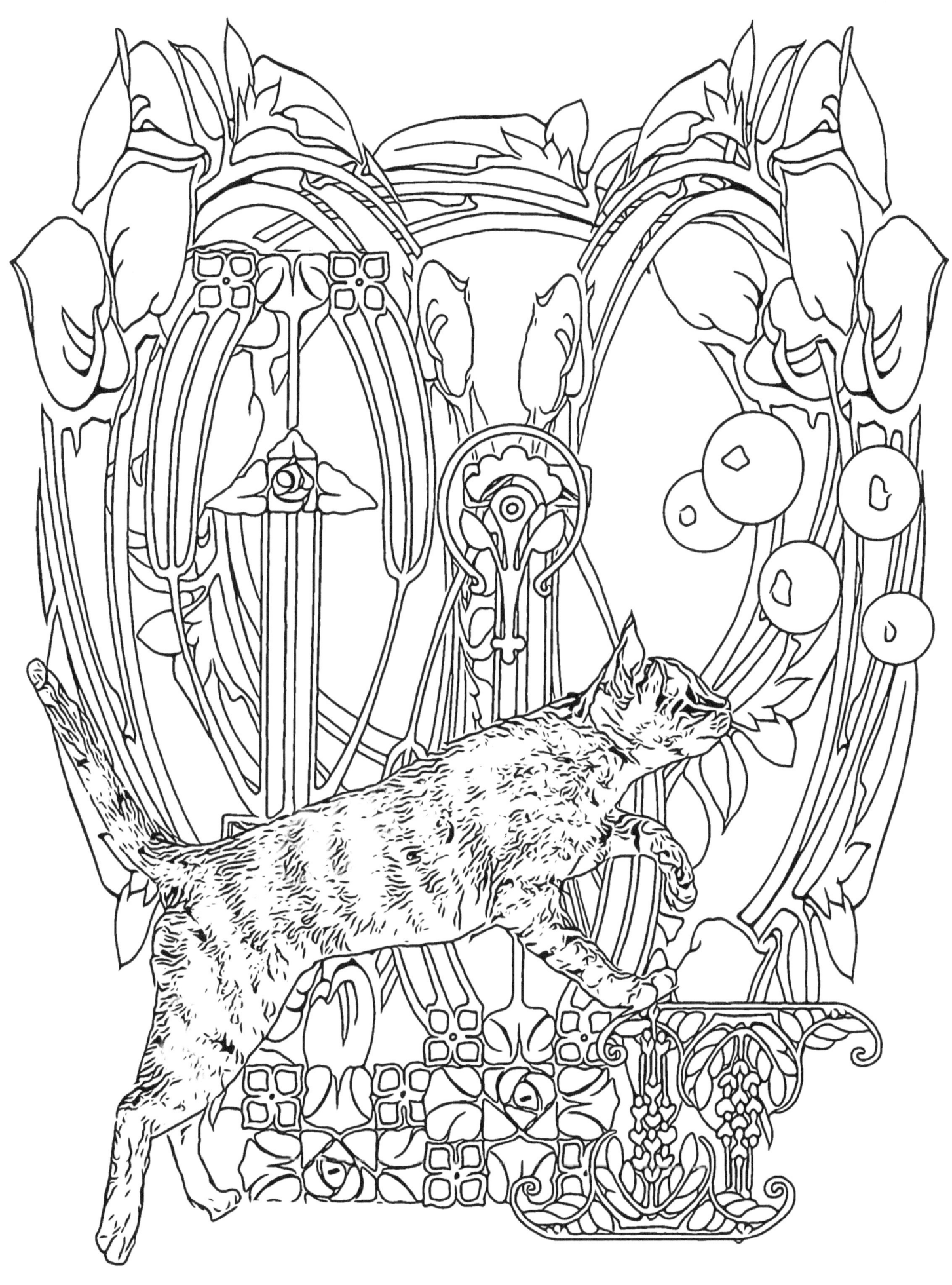

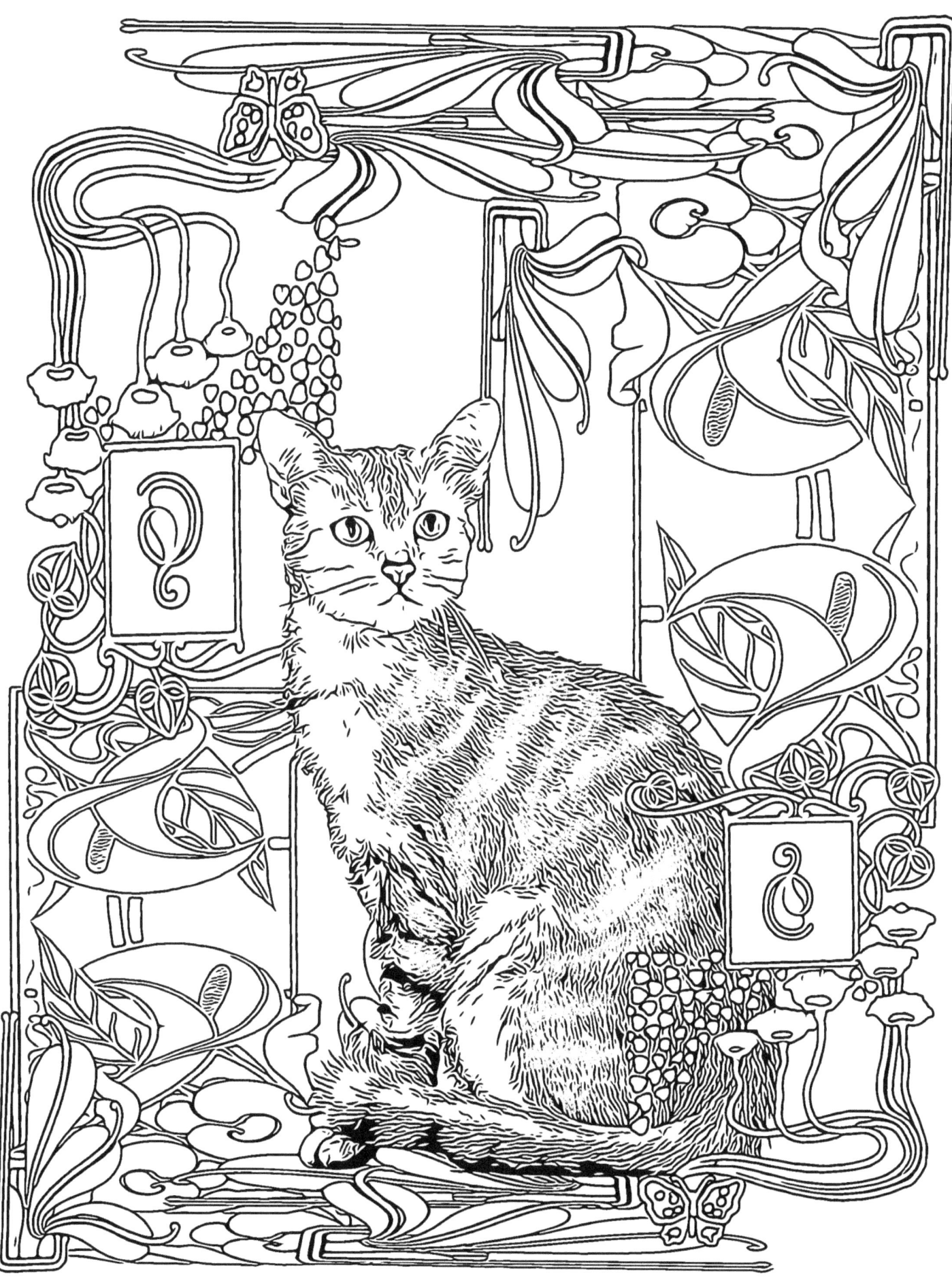

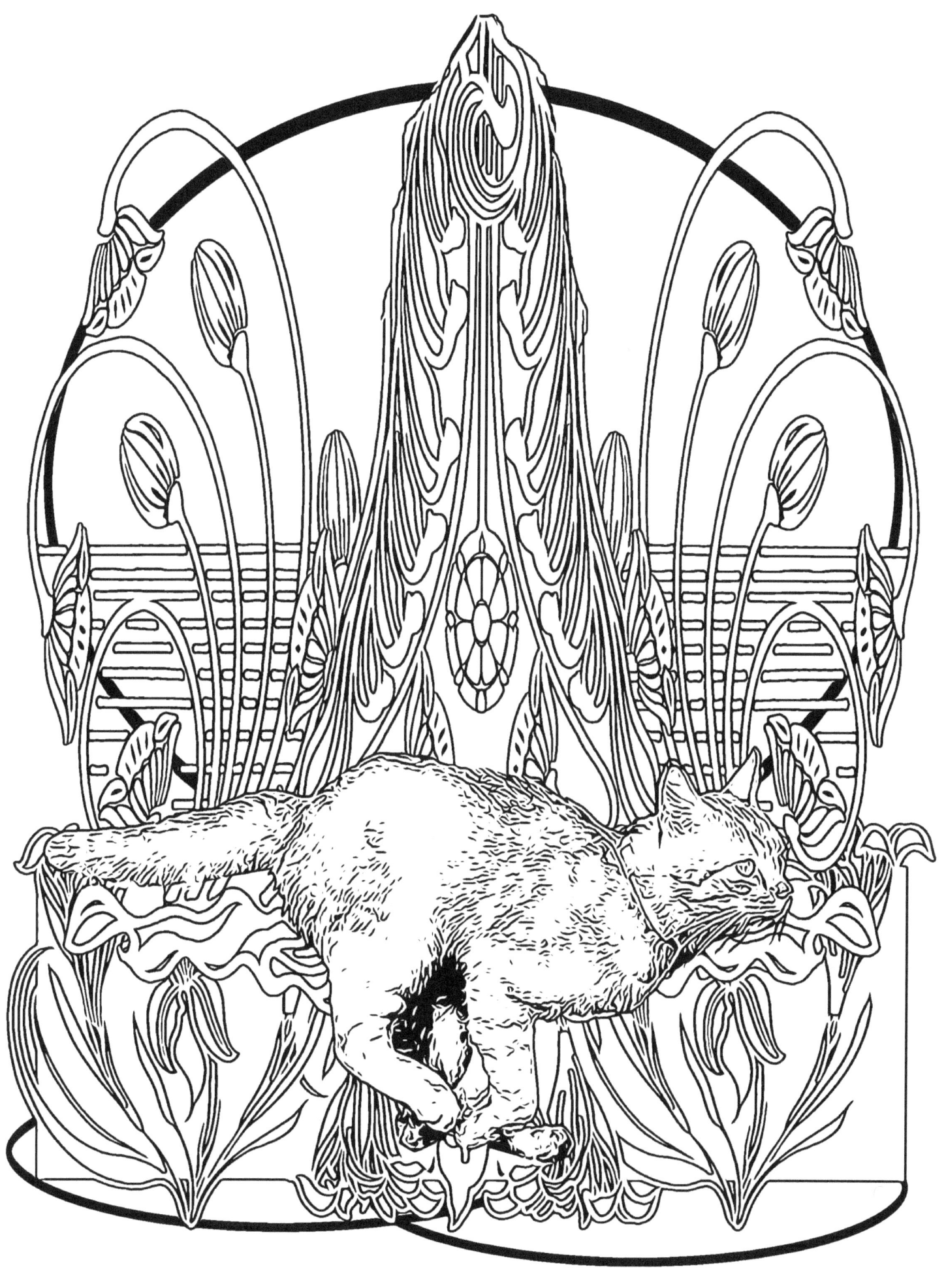

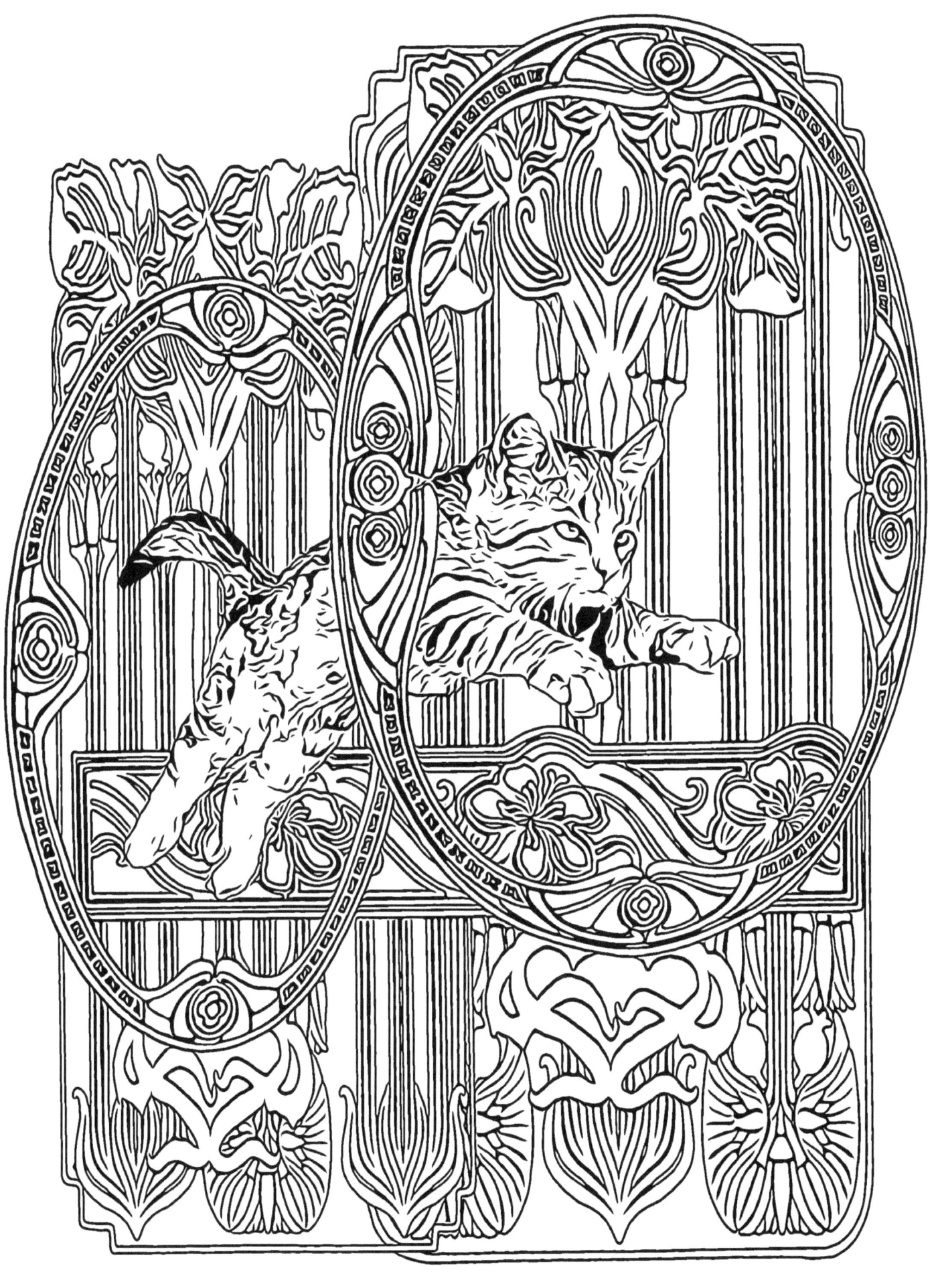

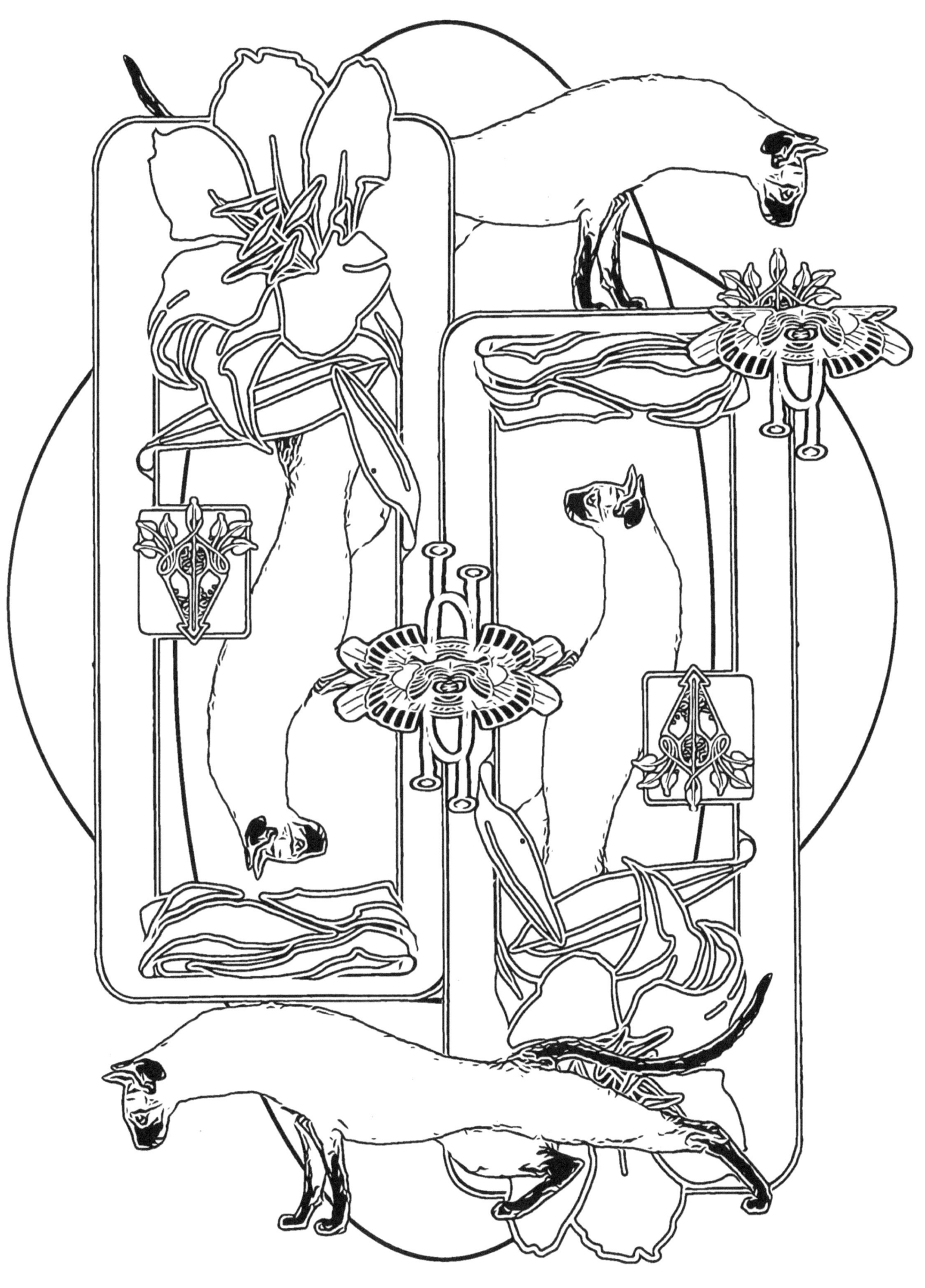

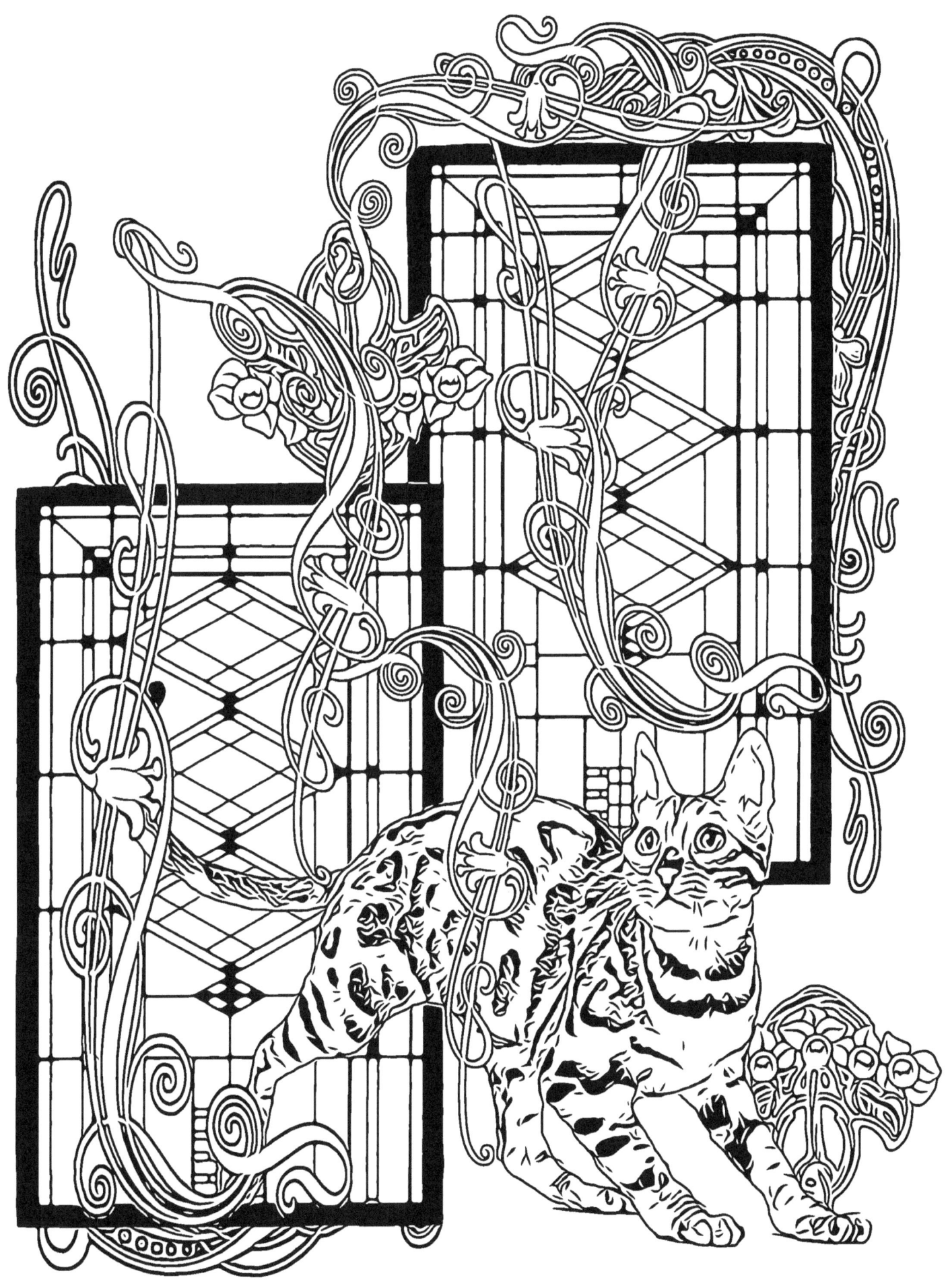

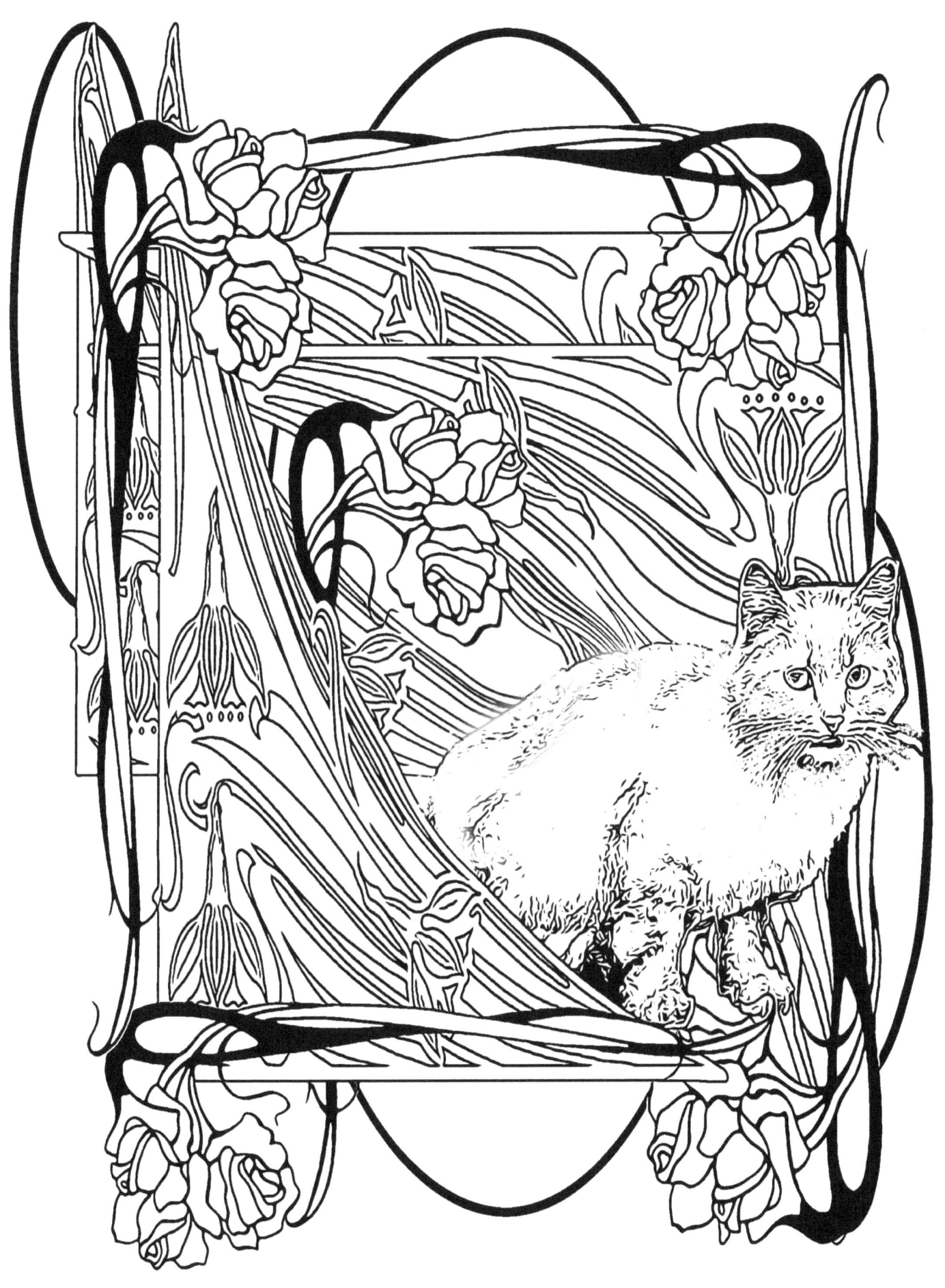

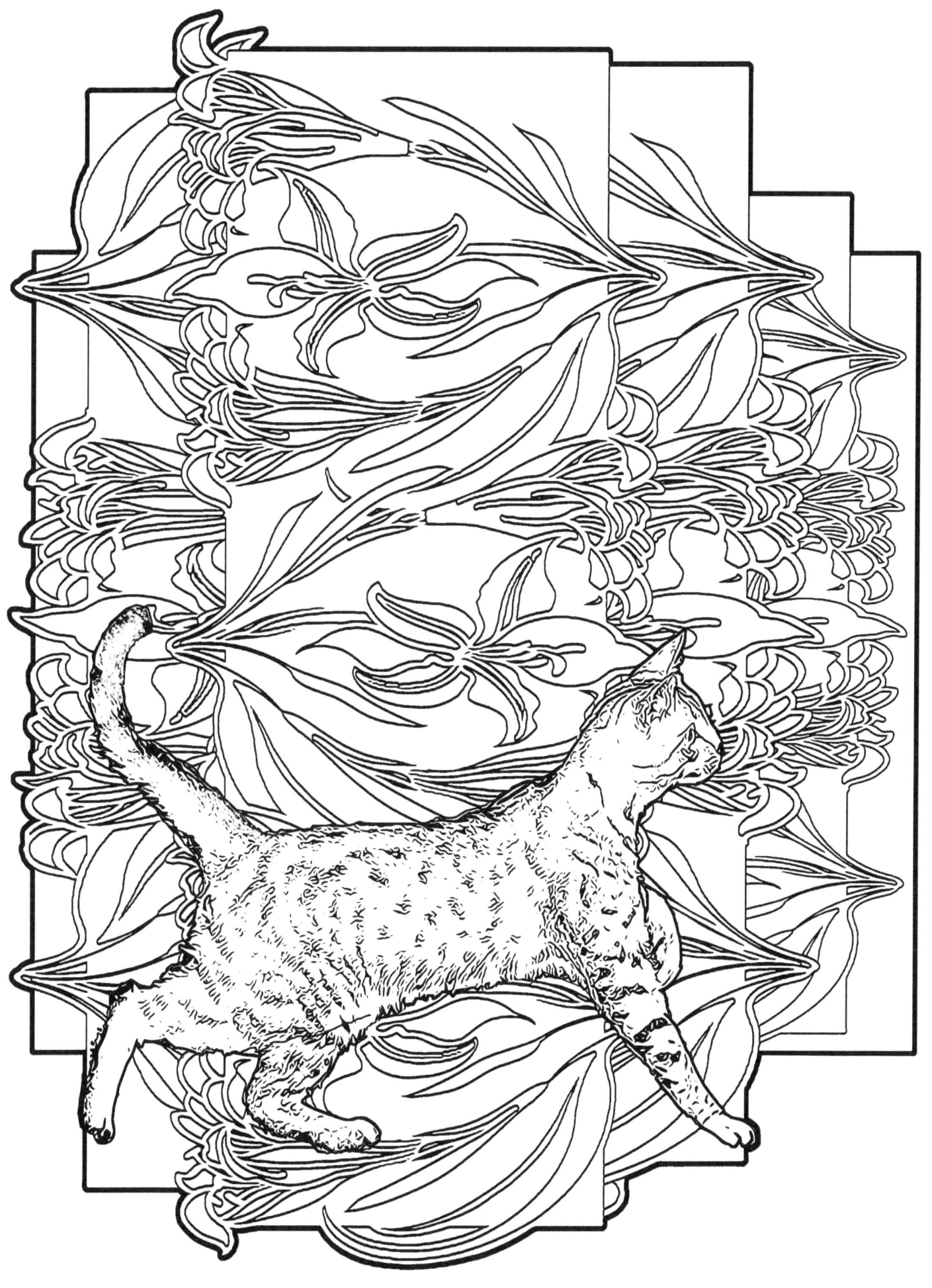

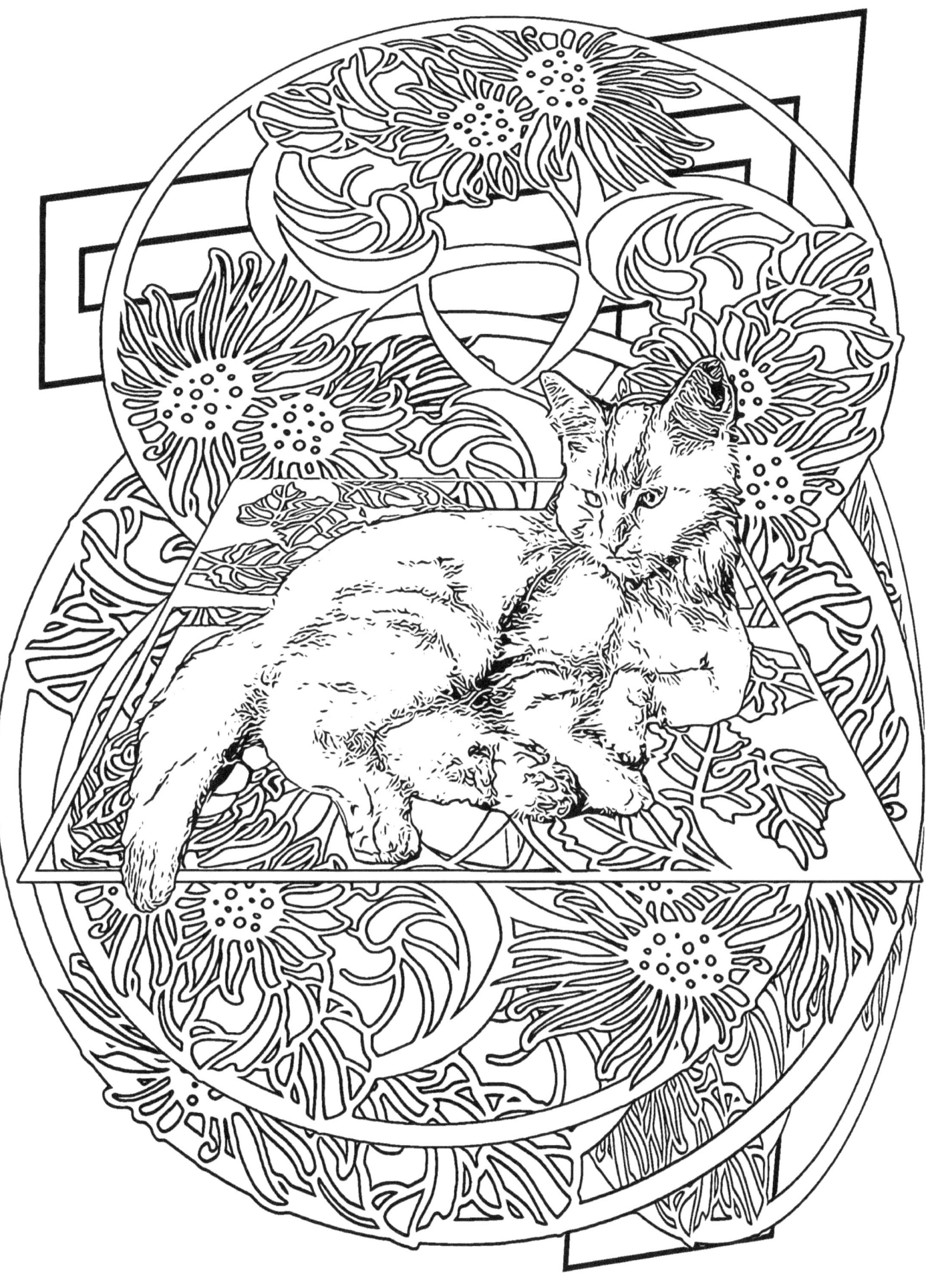

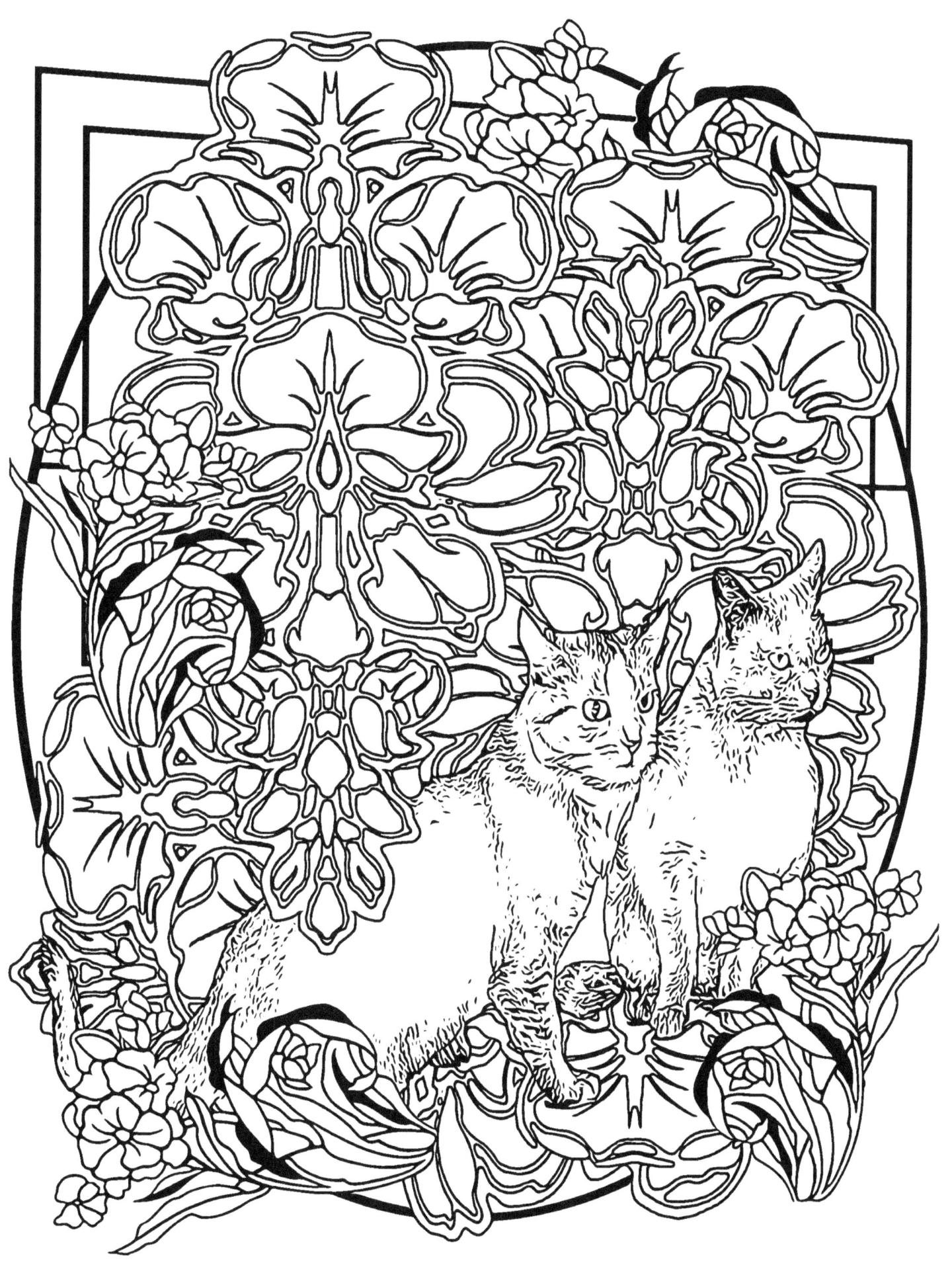

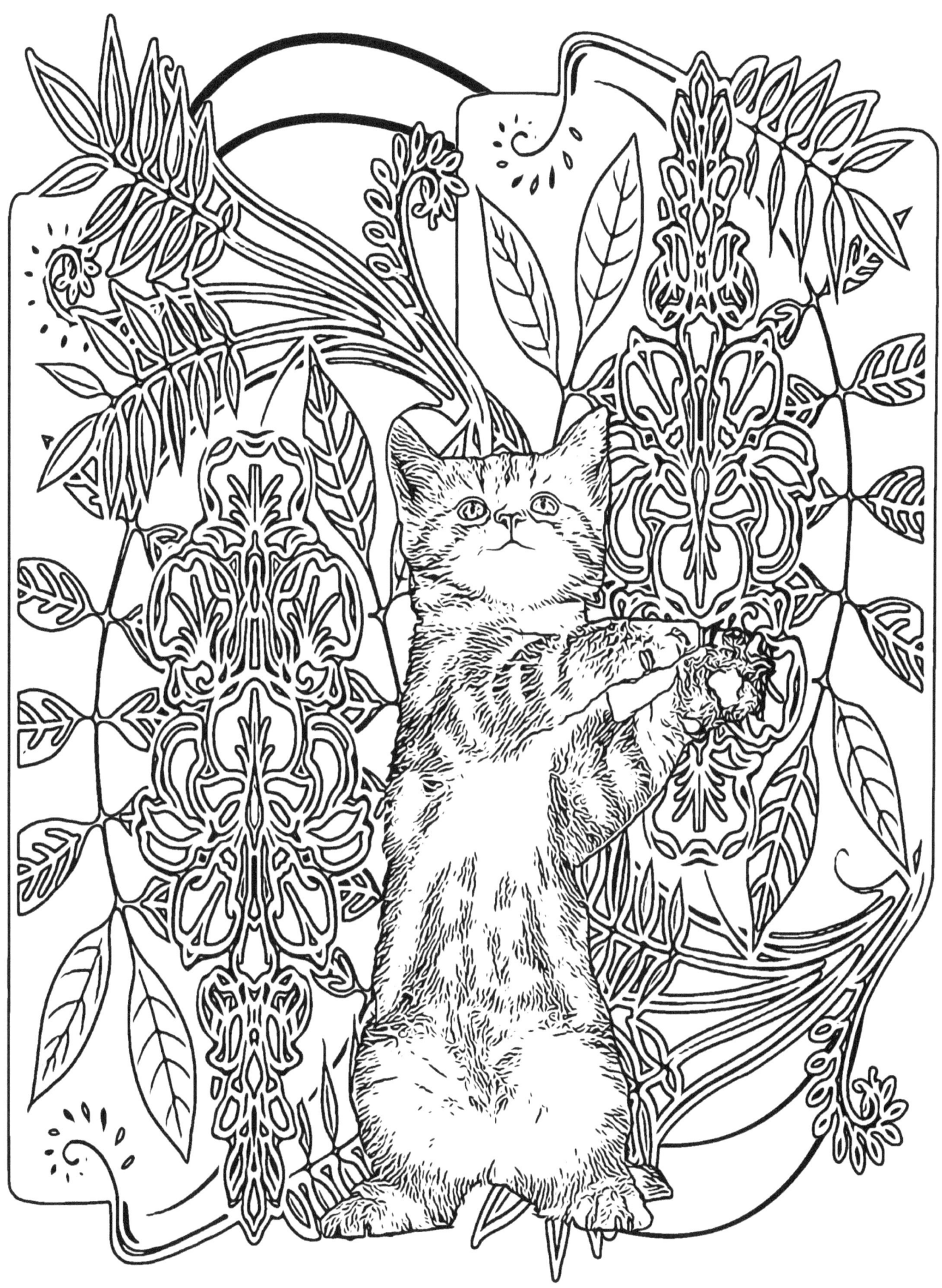

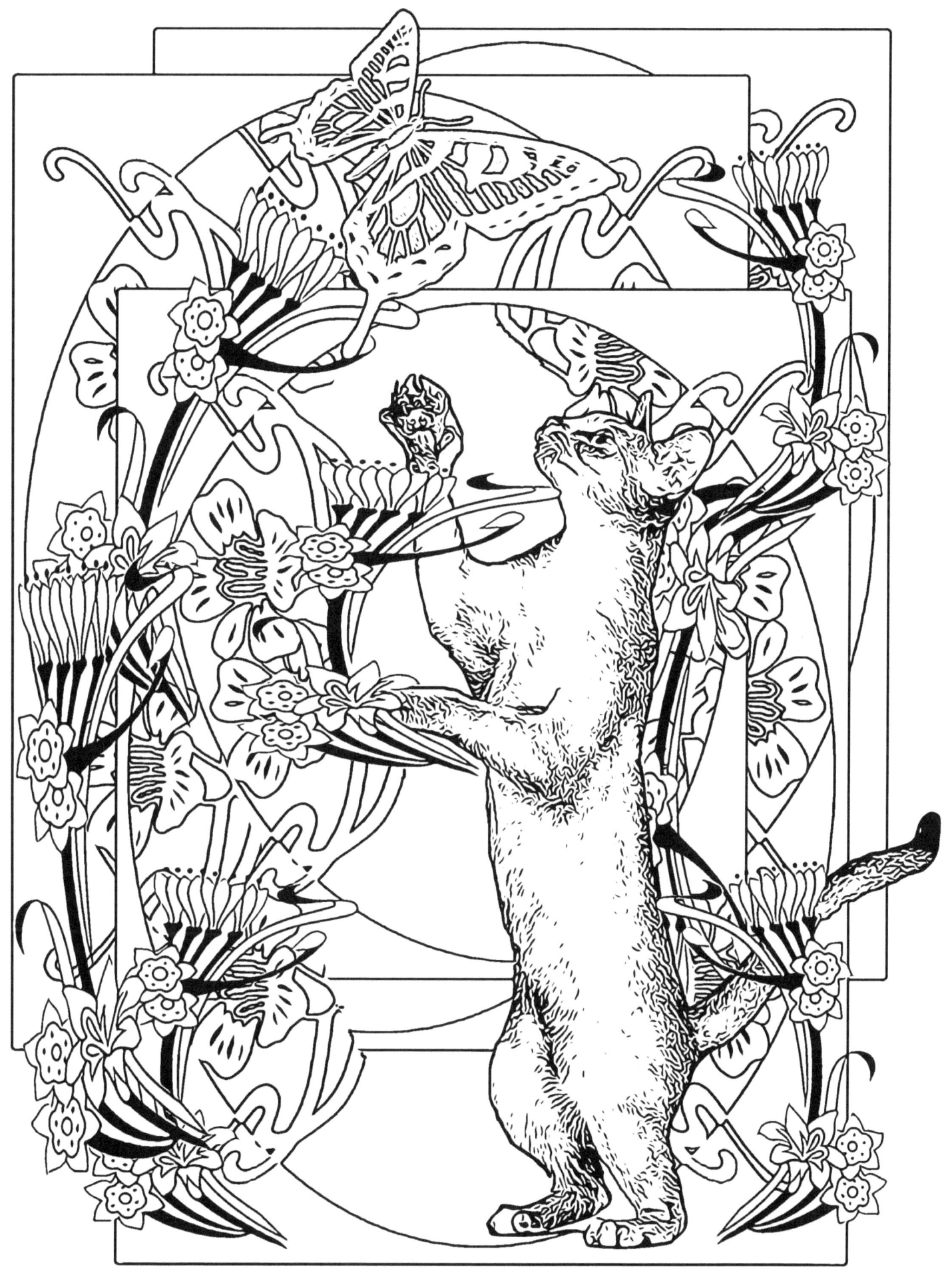

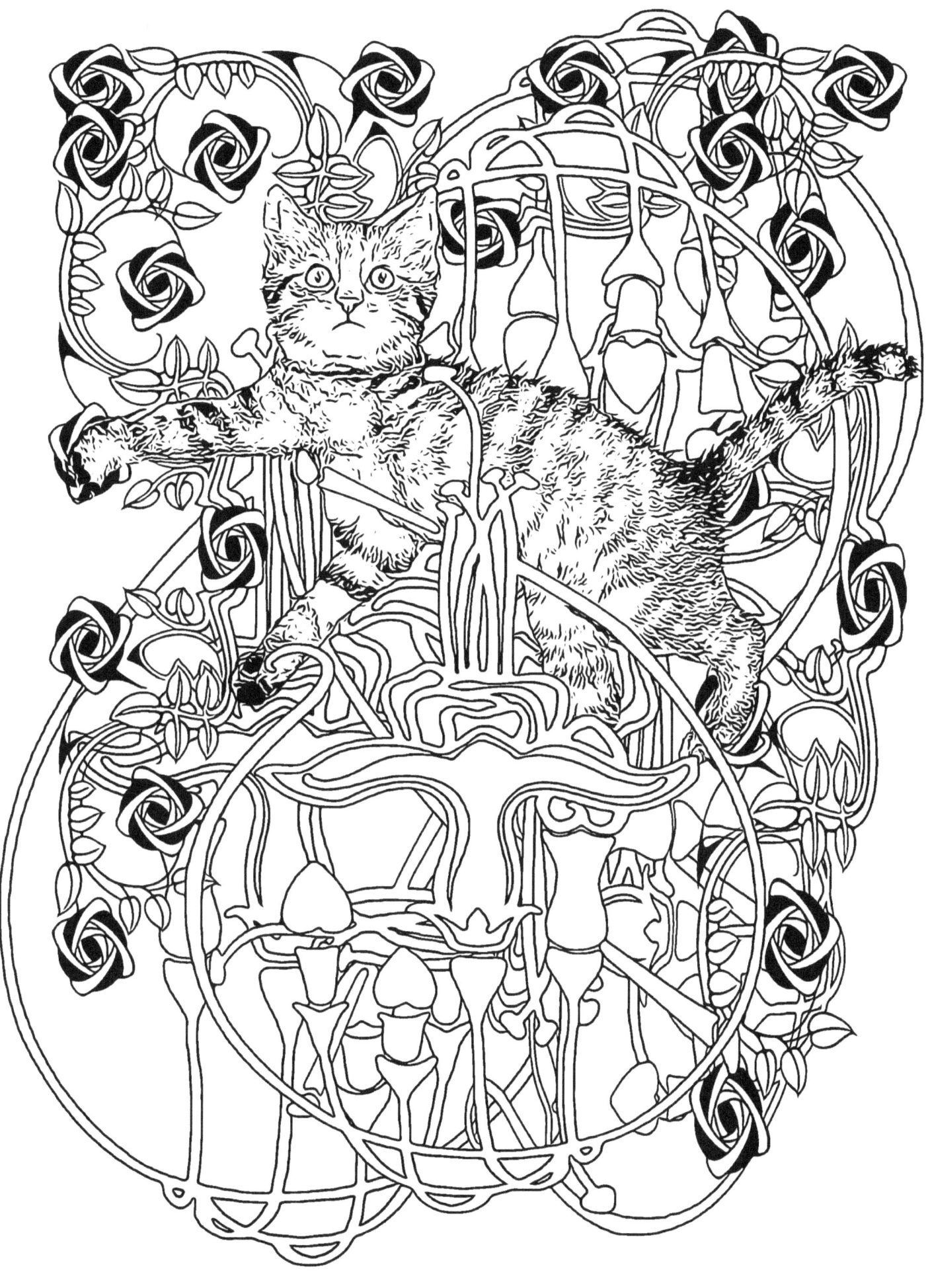

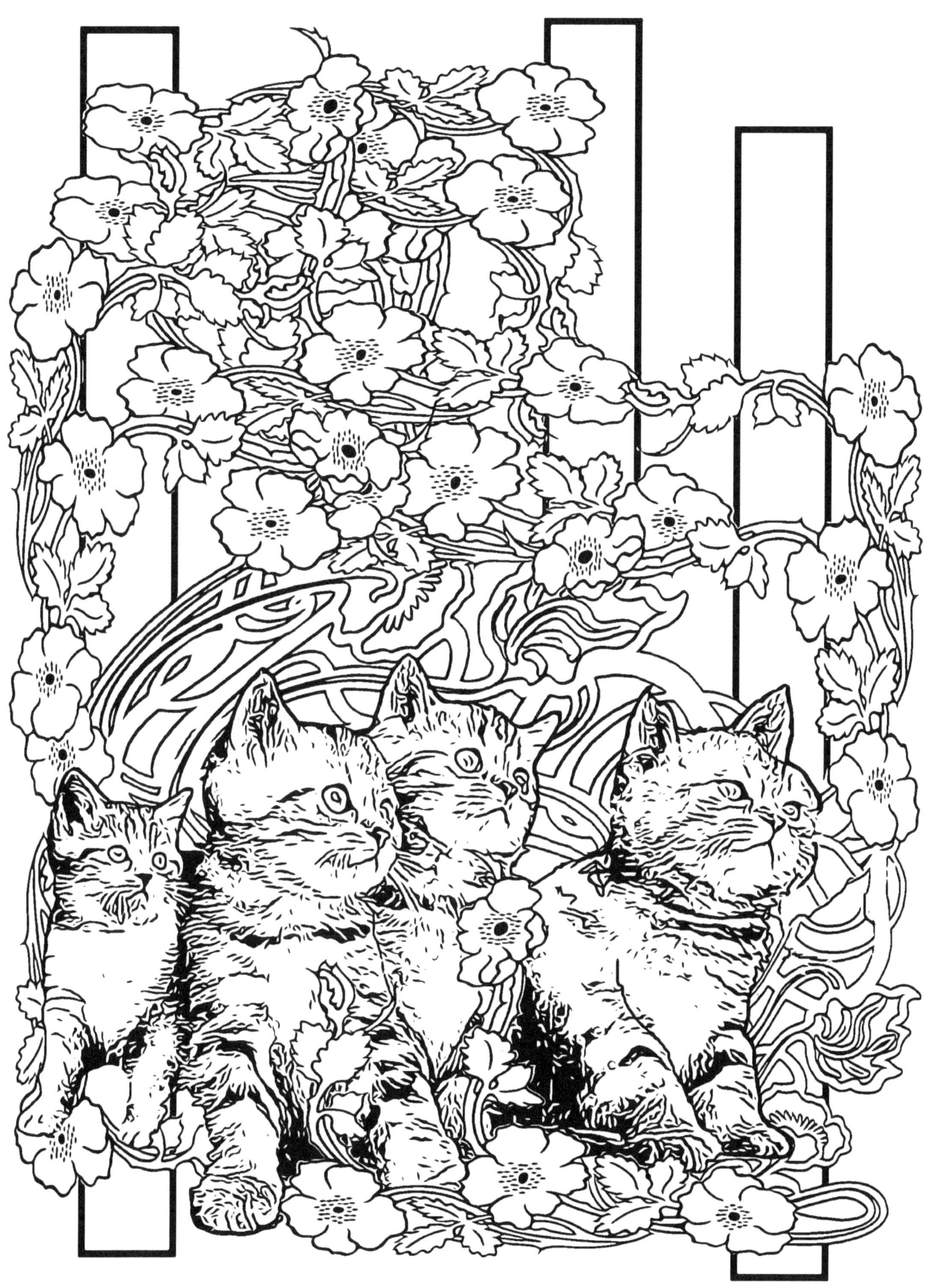

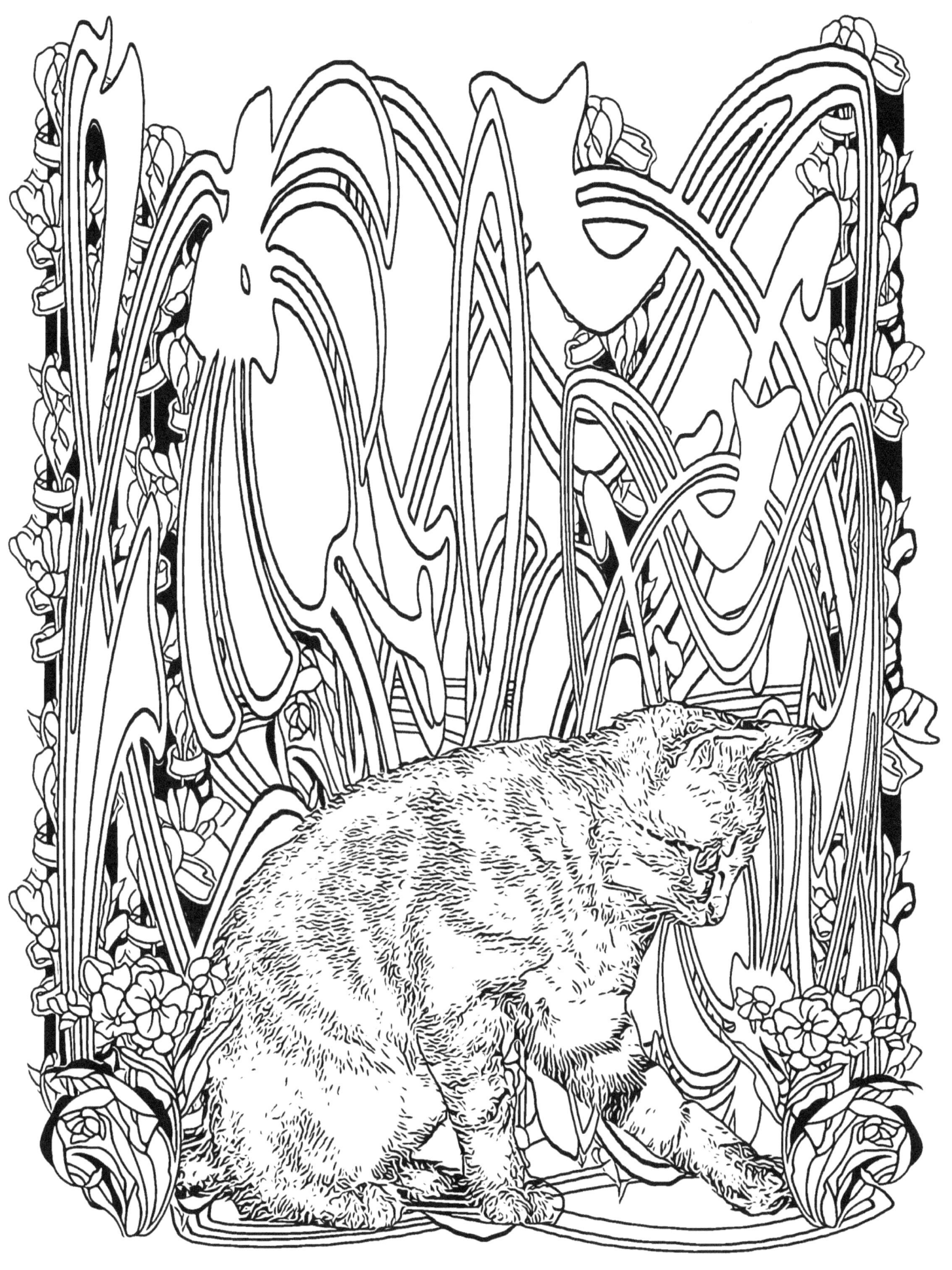

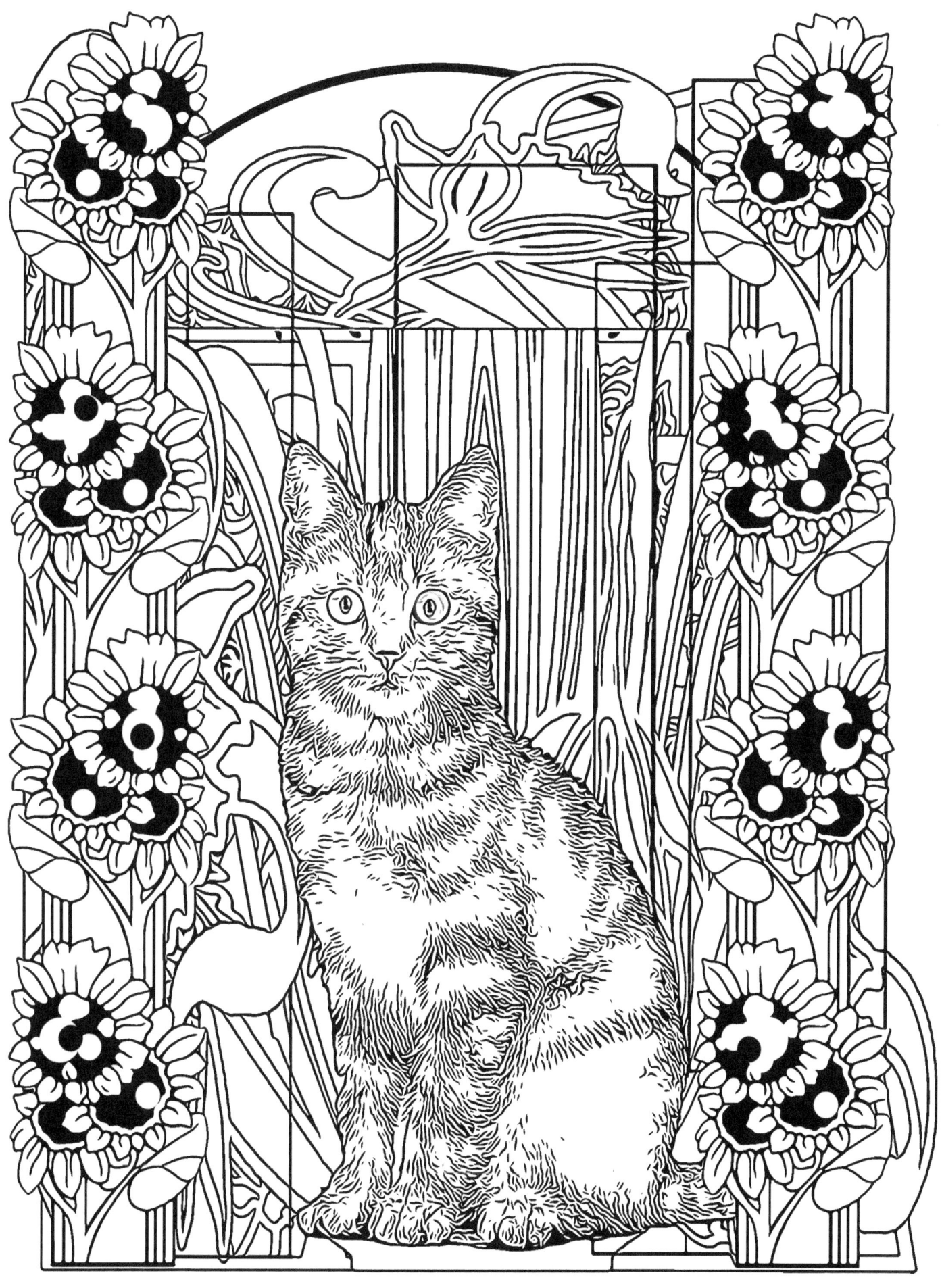

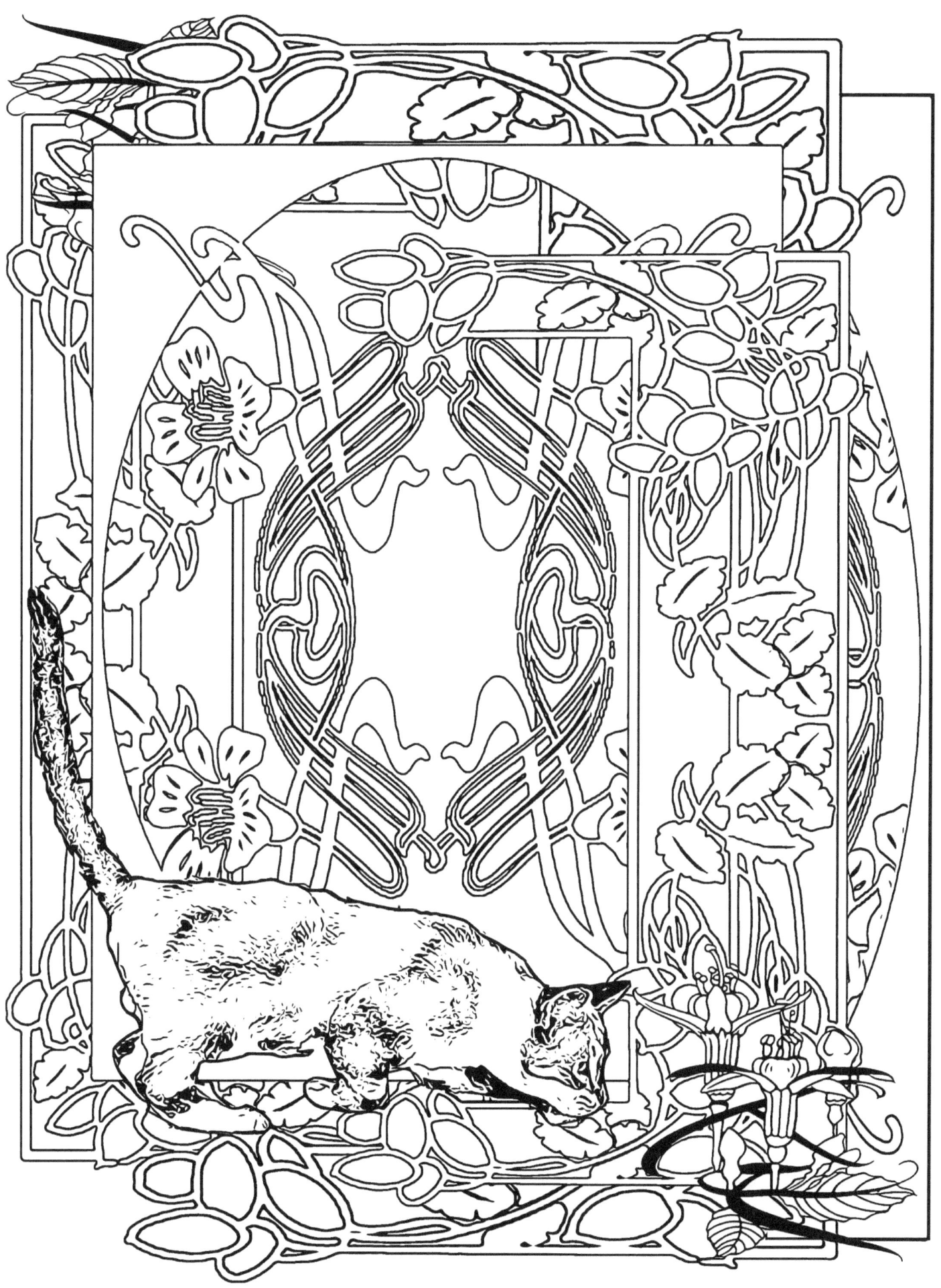

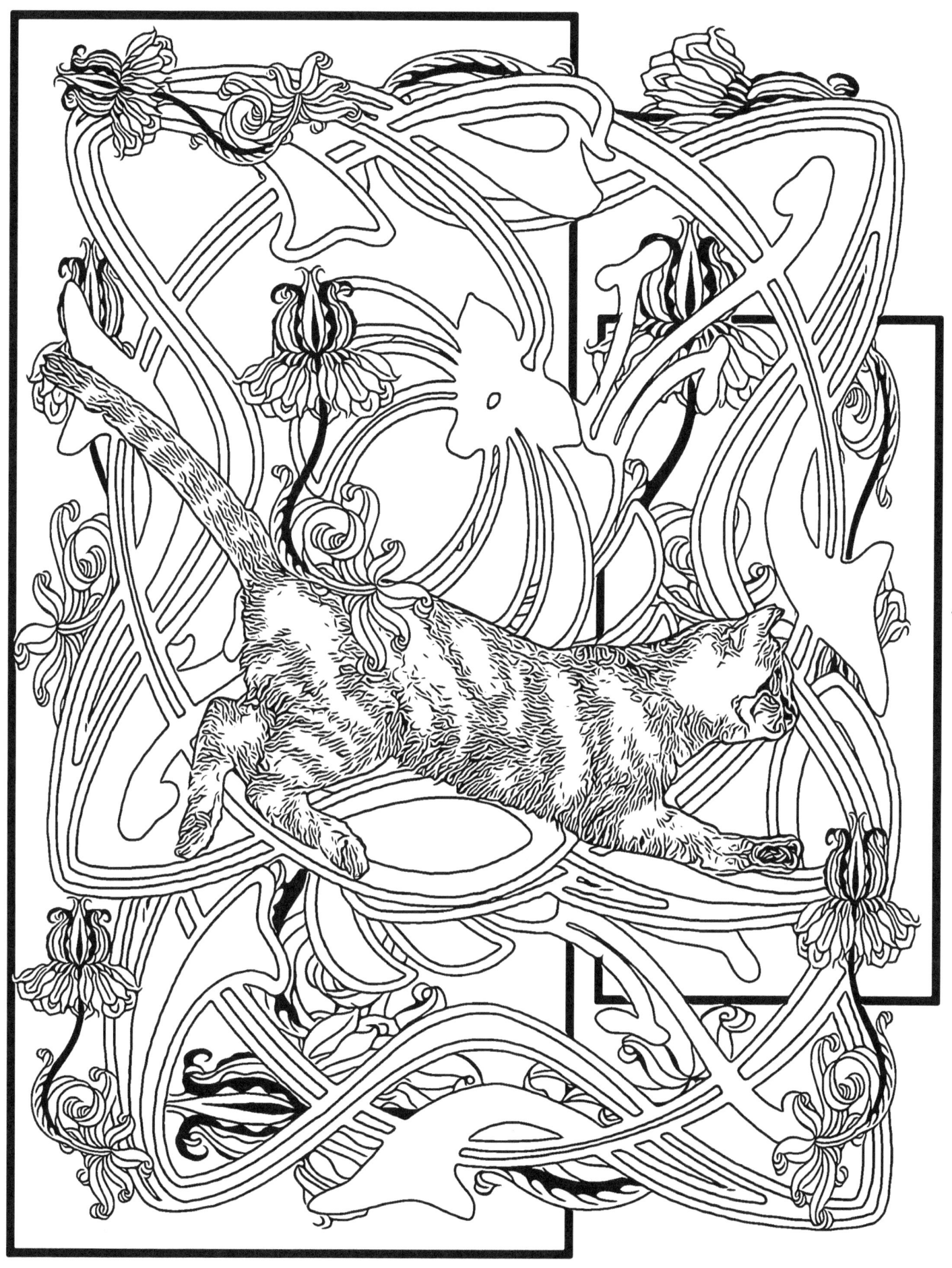

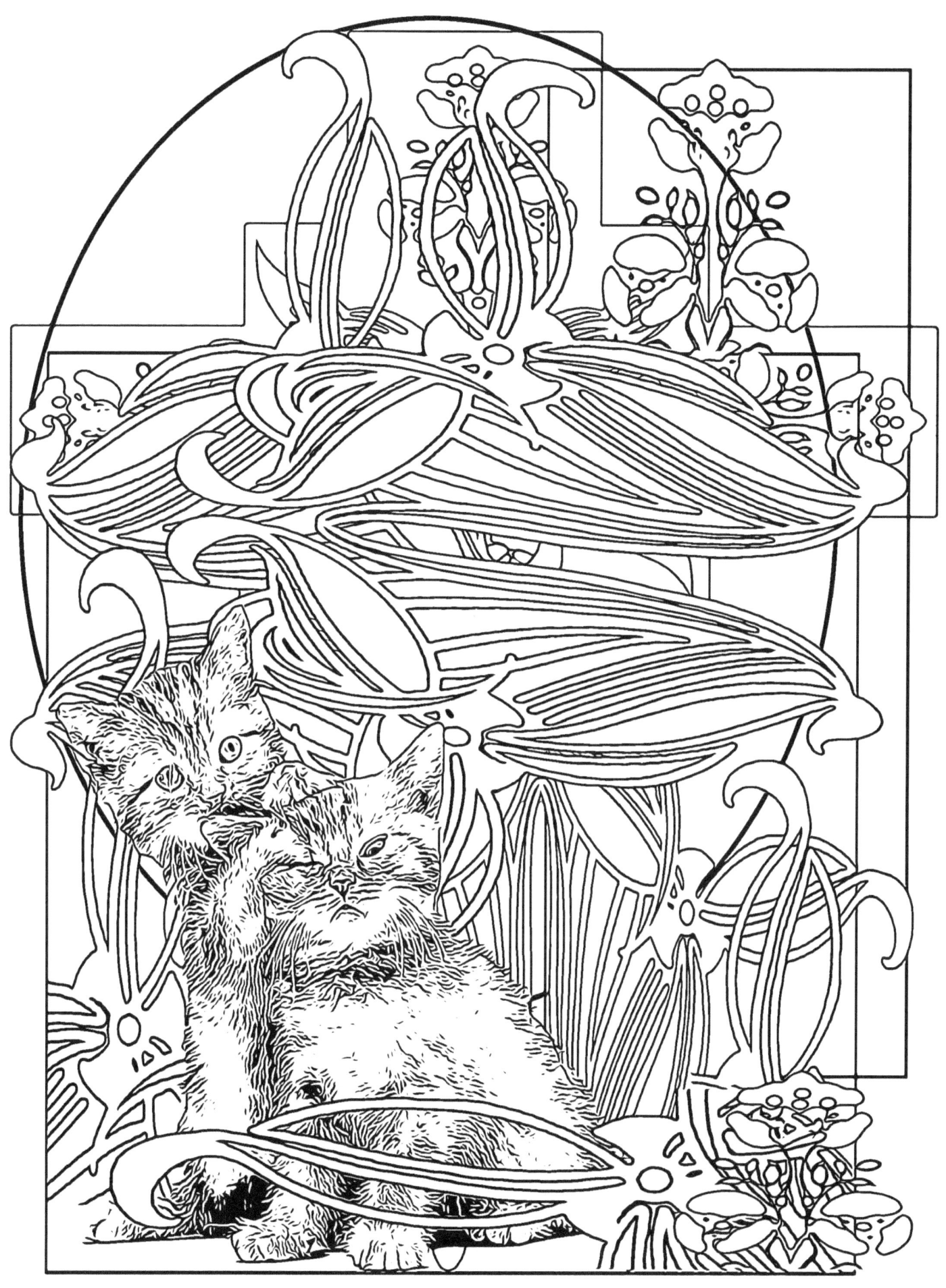

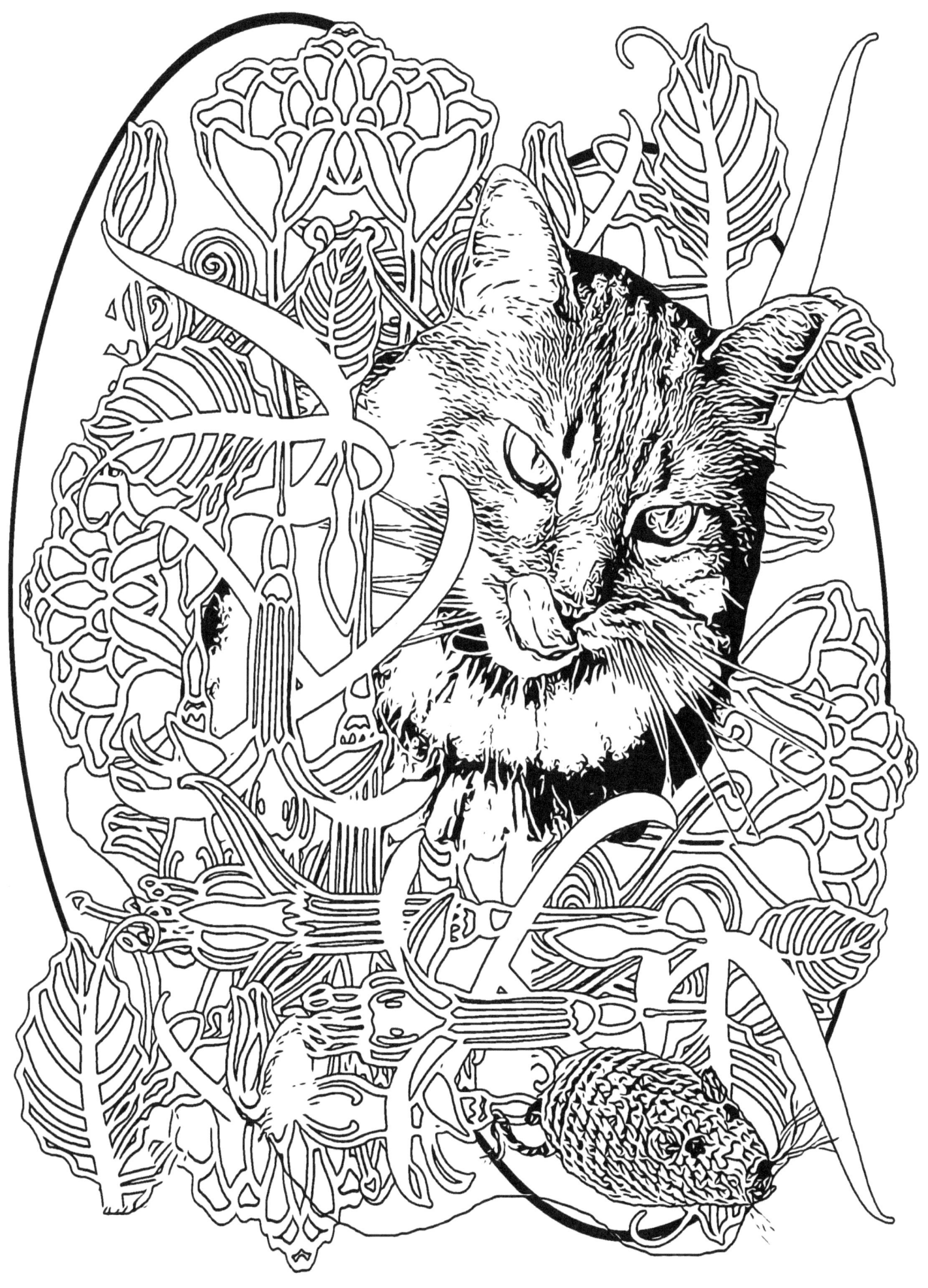

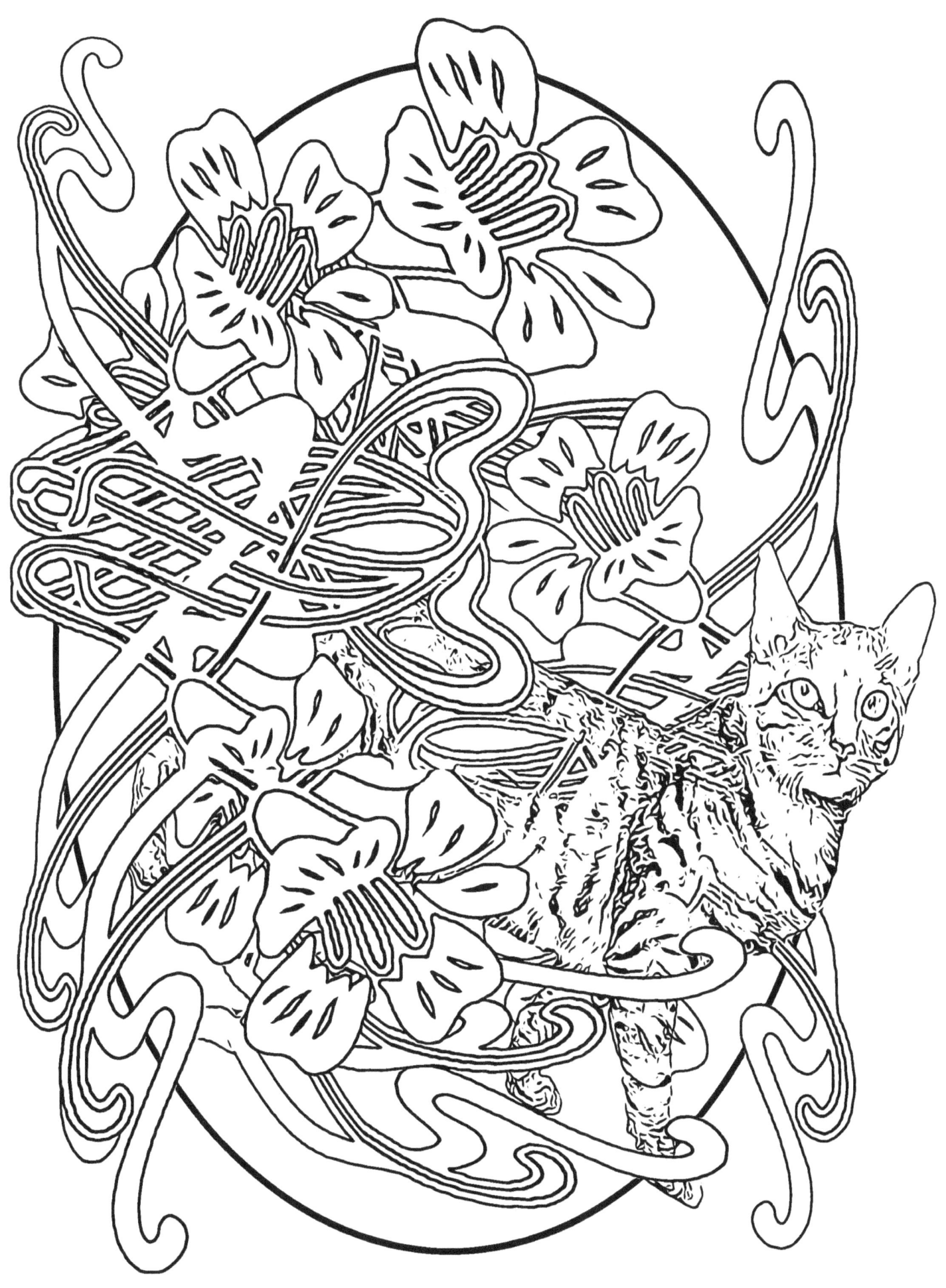

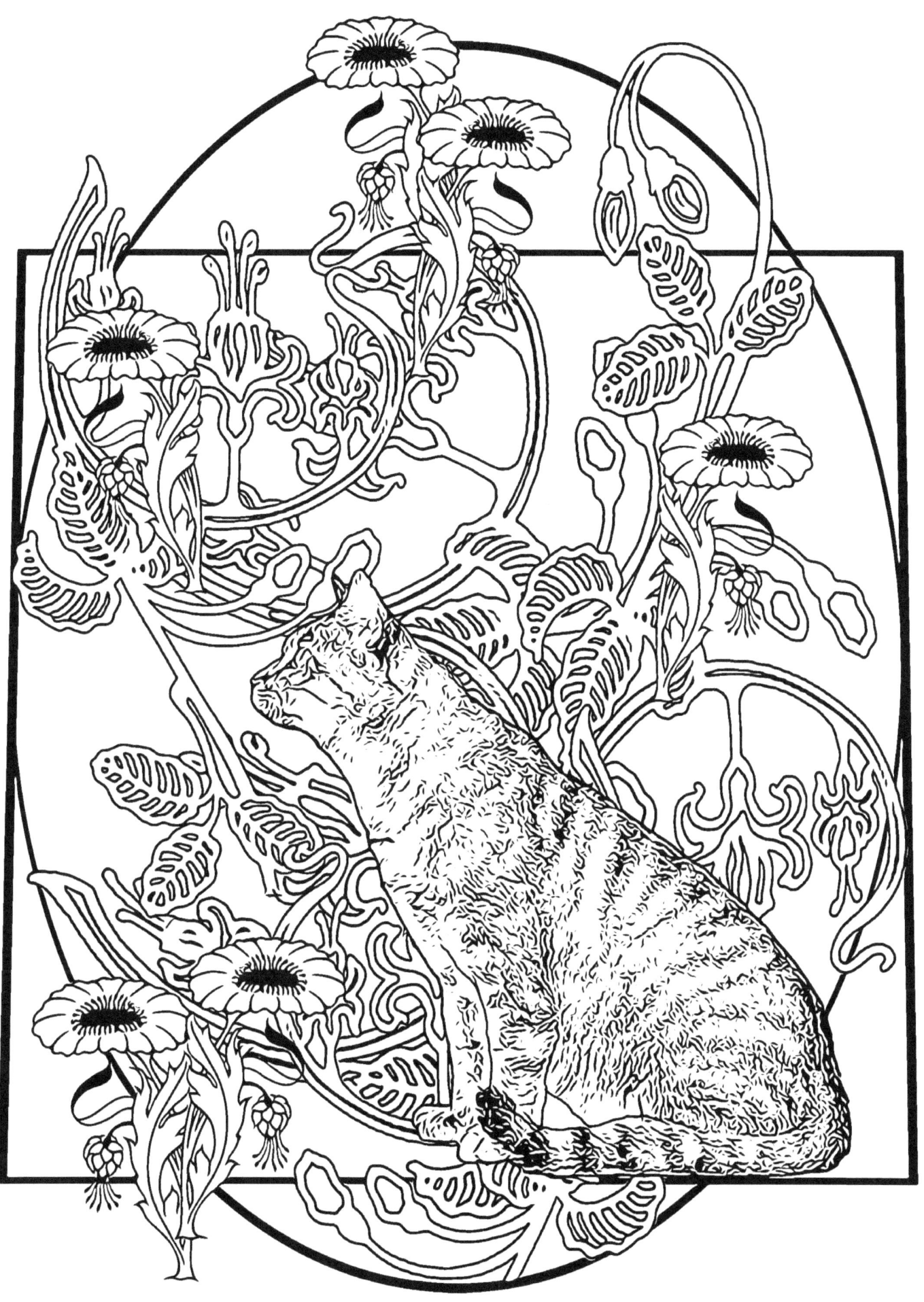

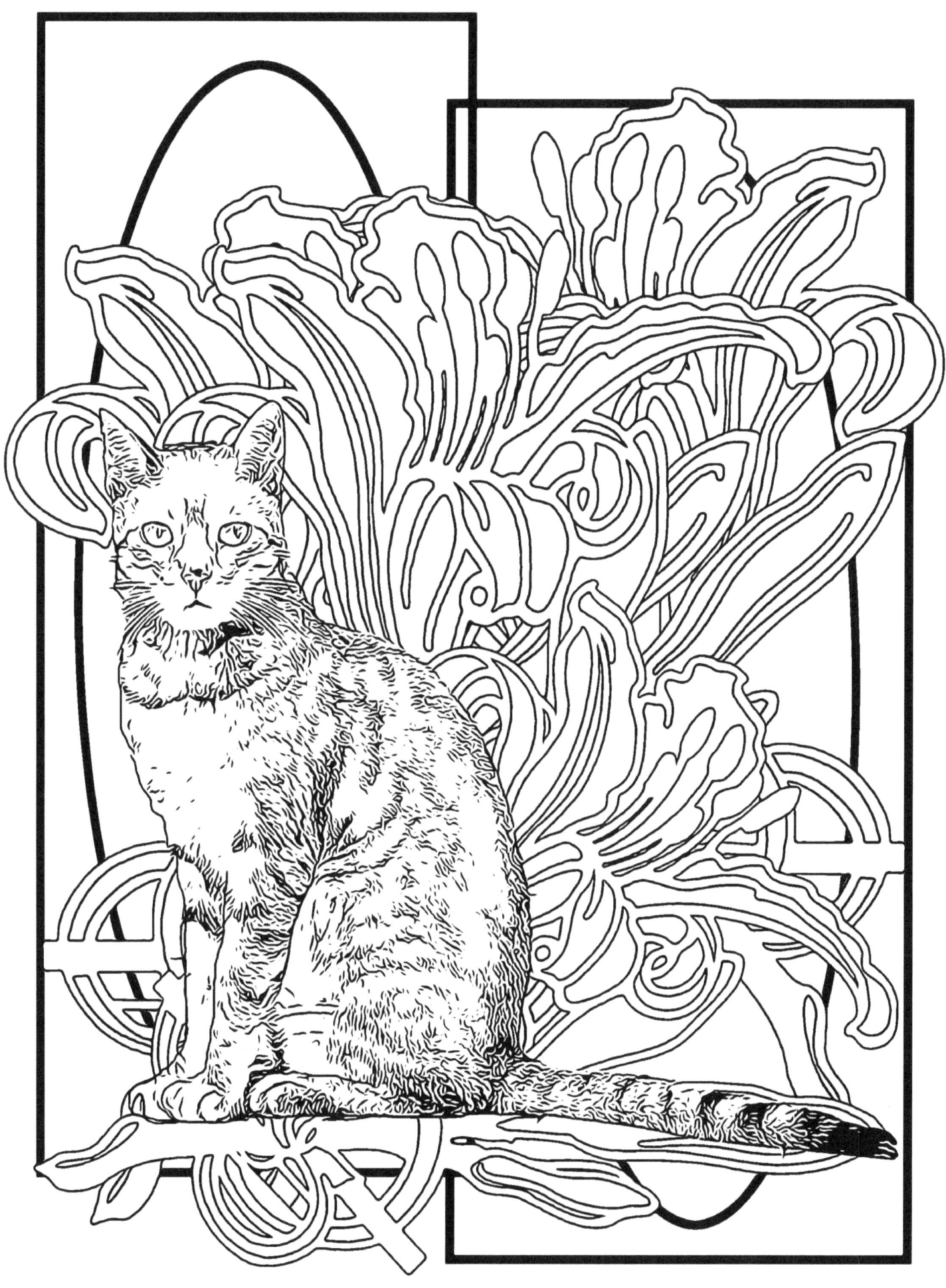

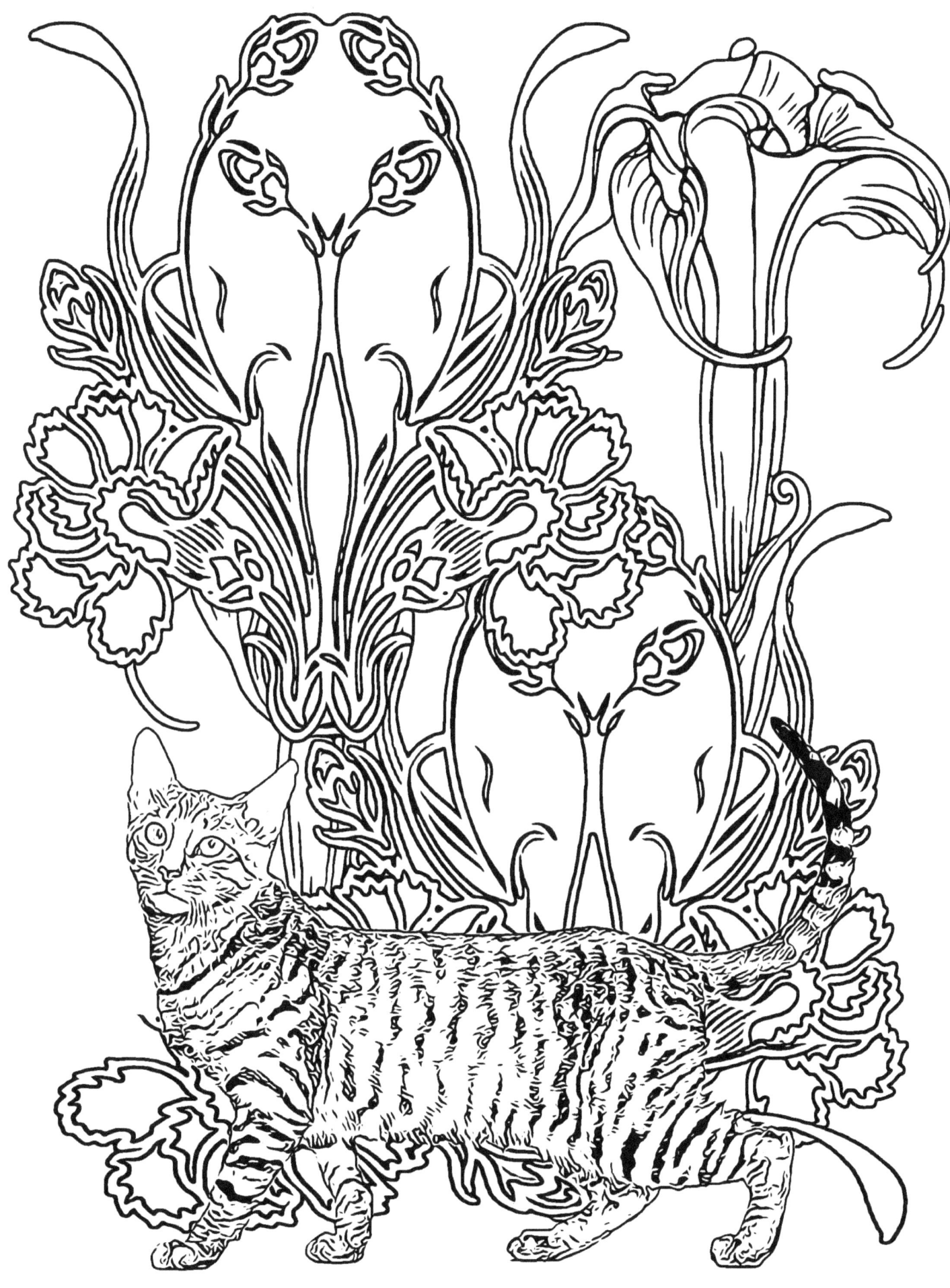

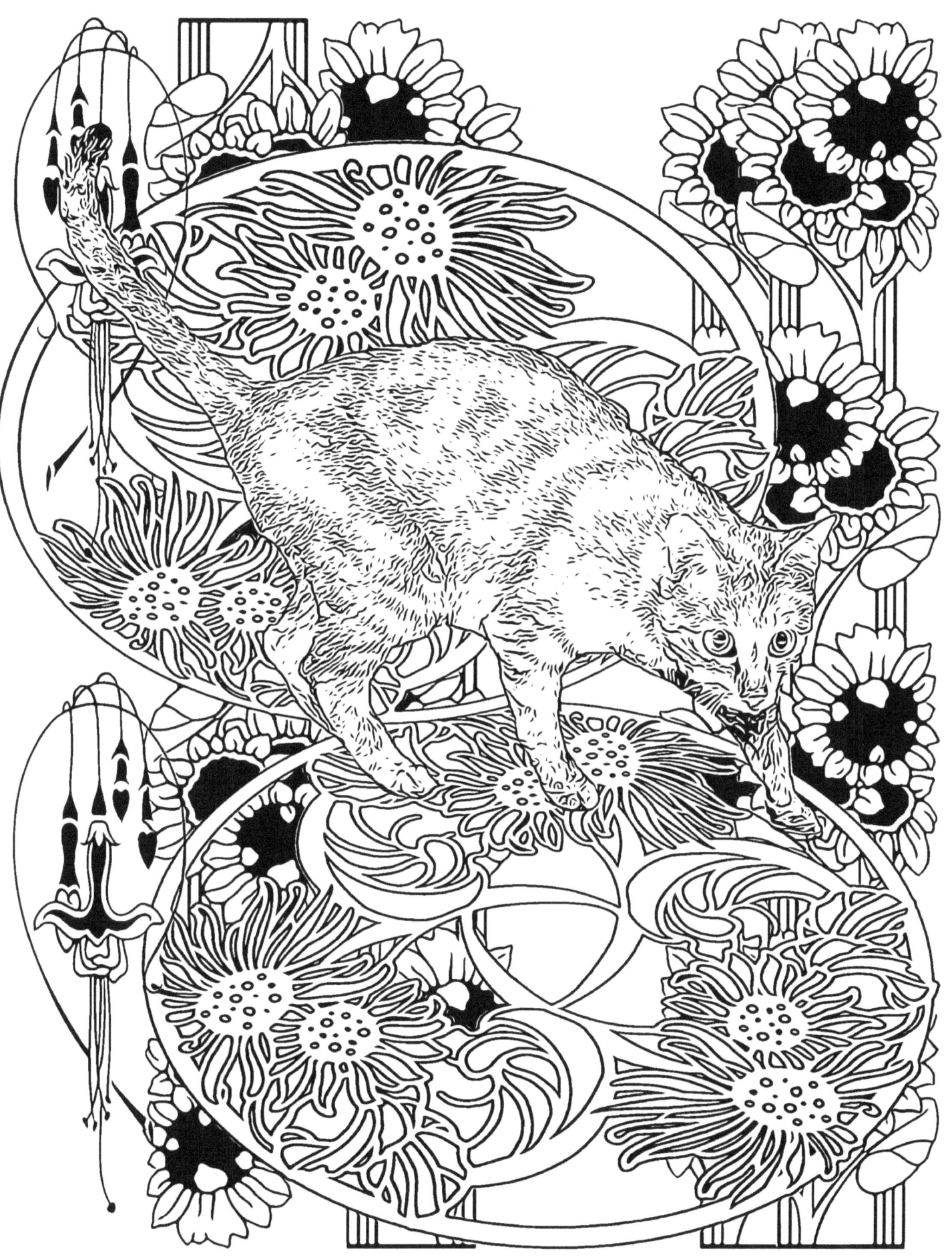

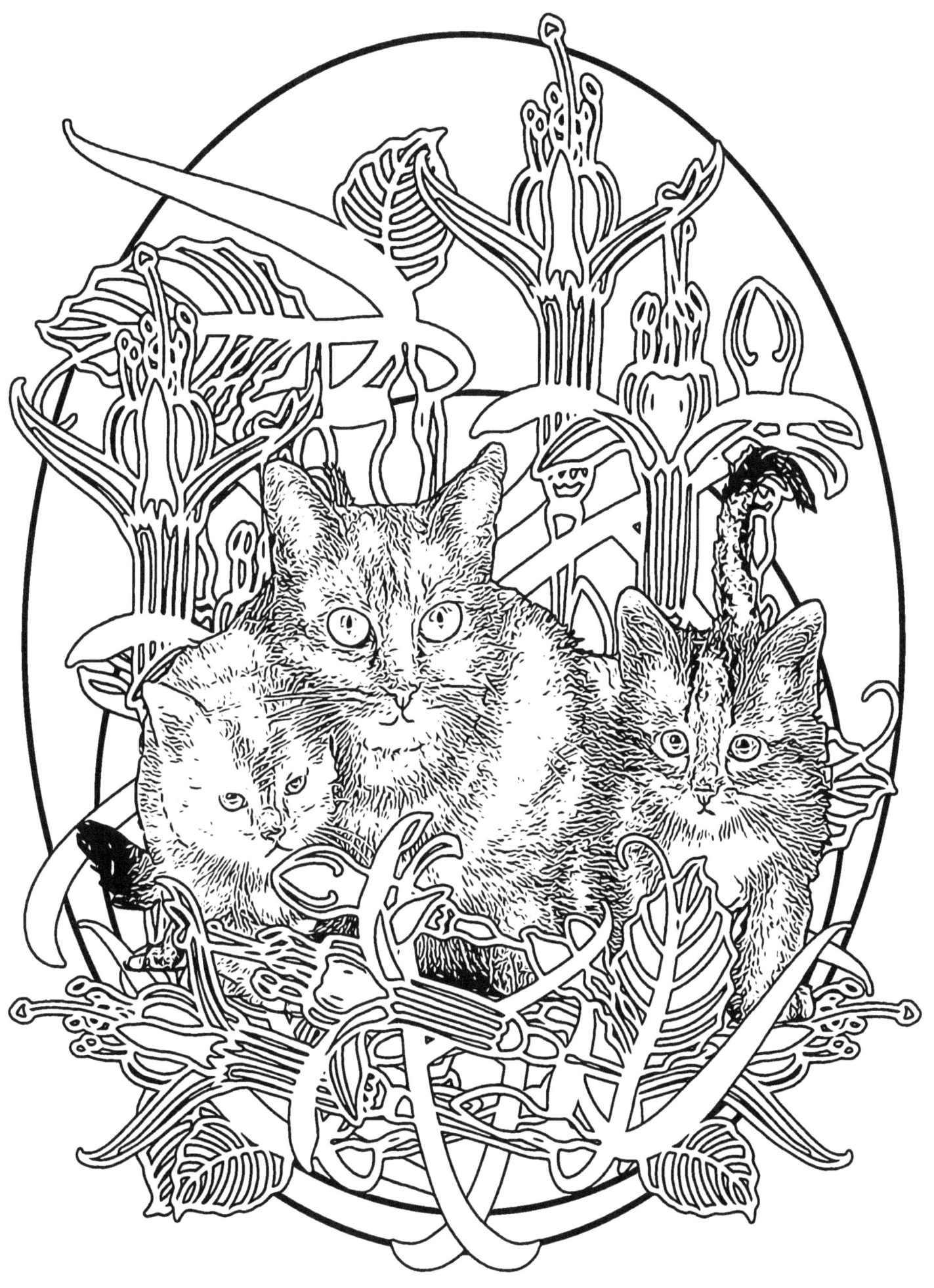

58

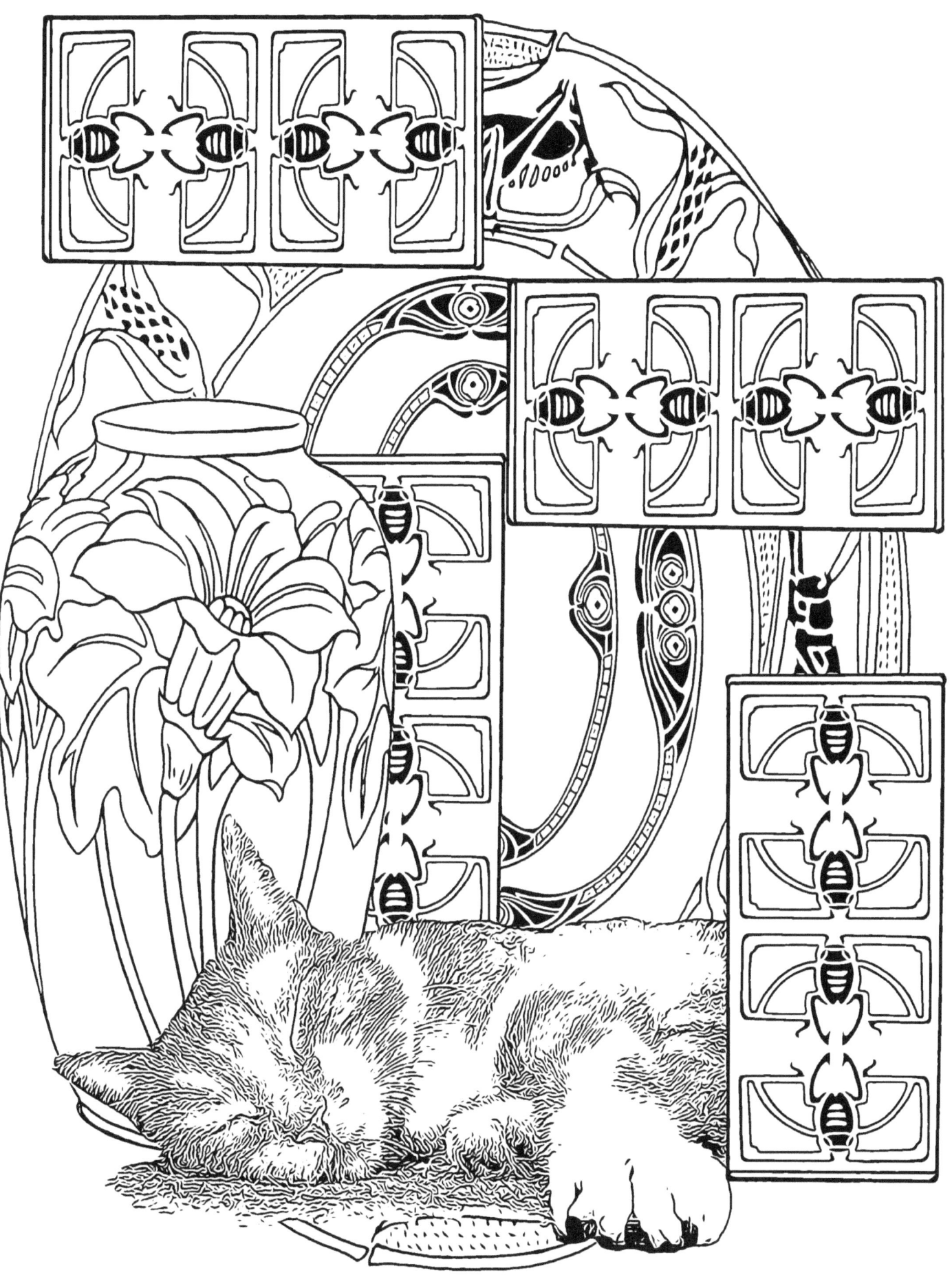

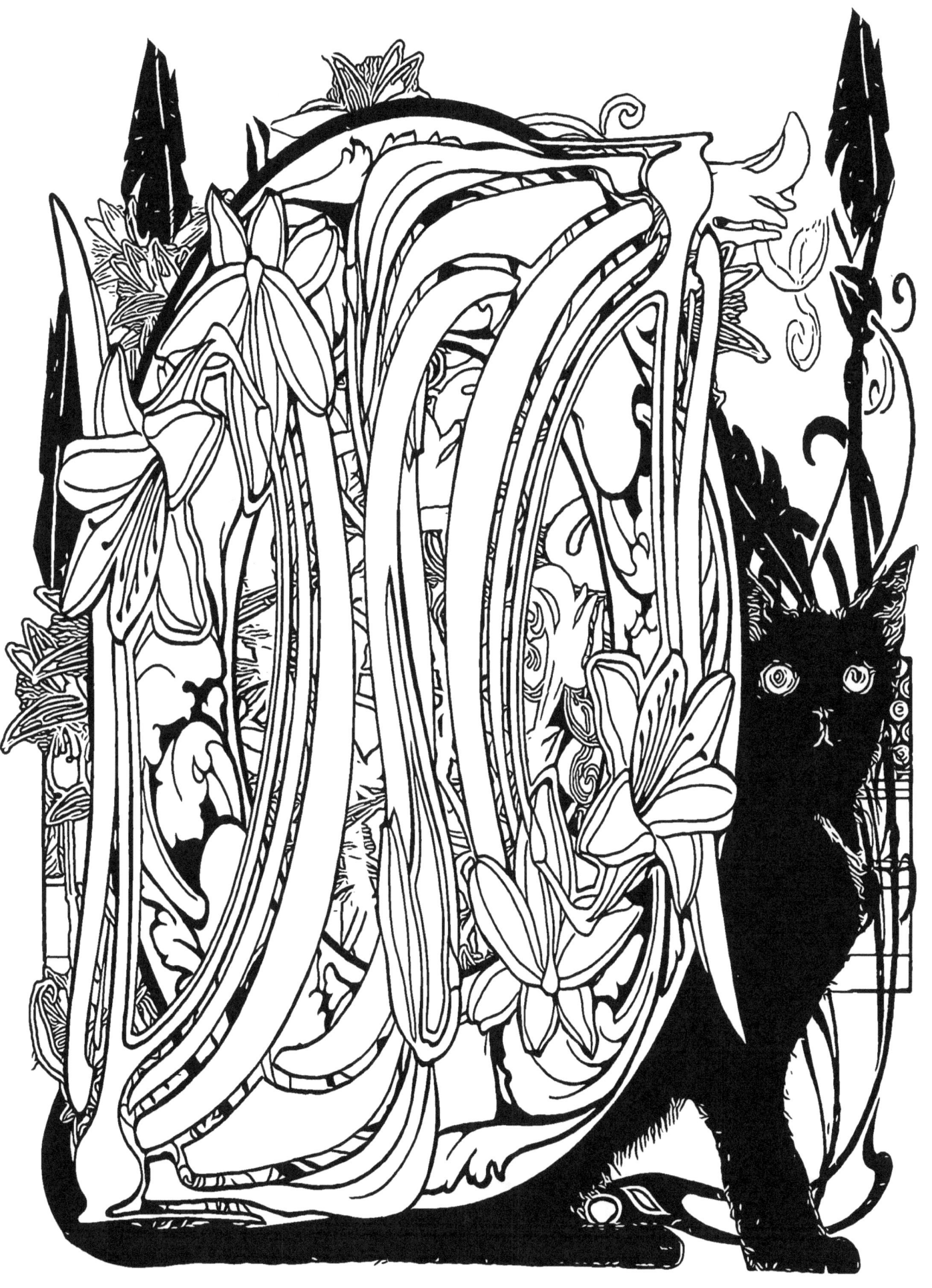

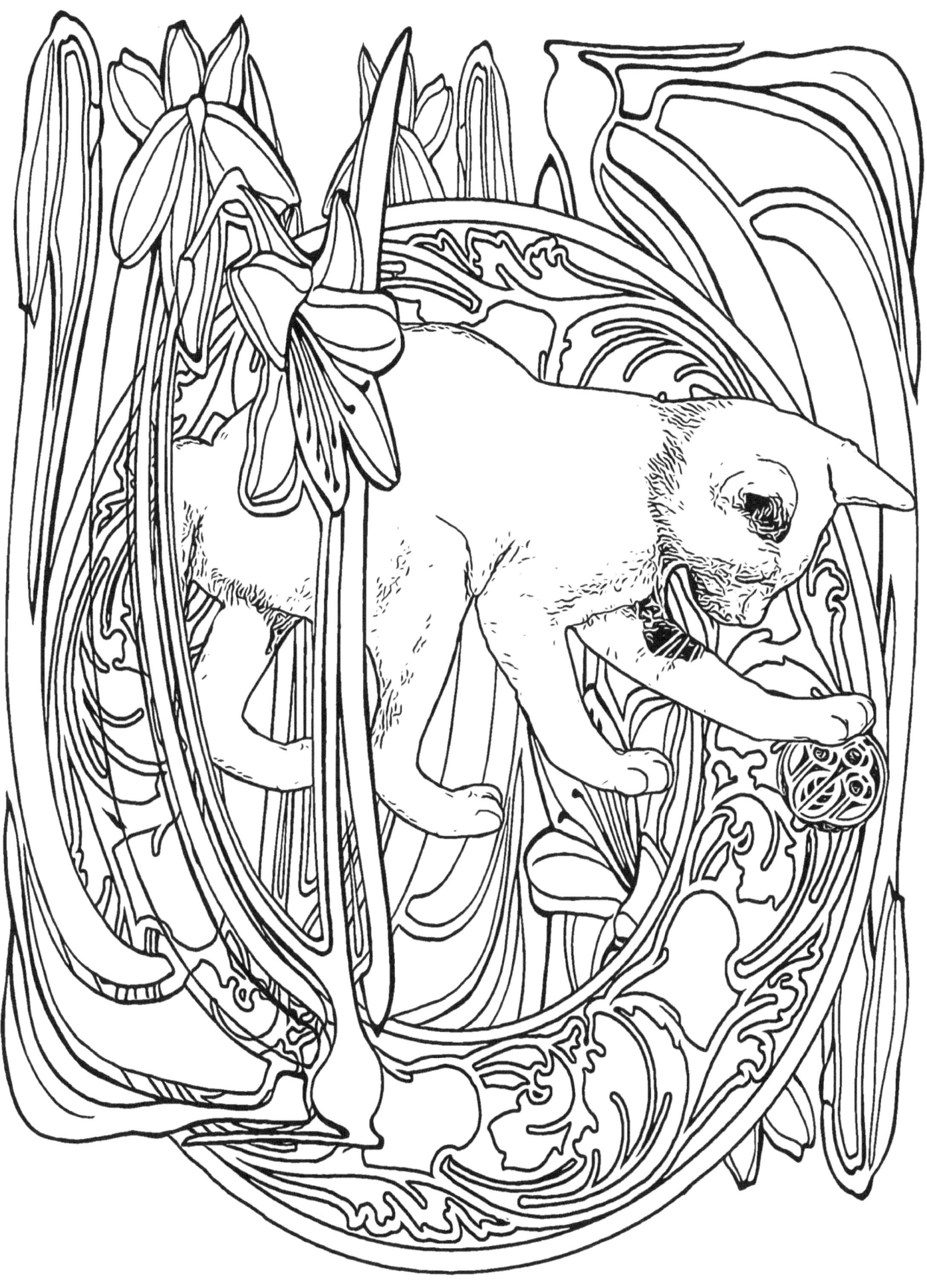

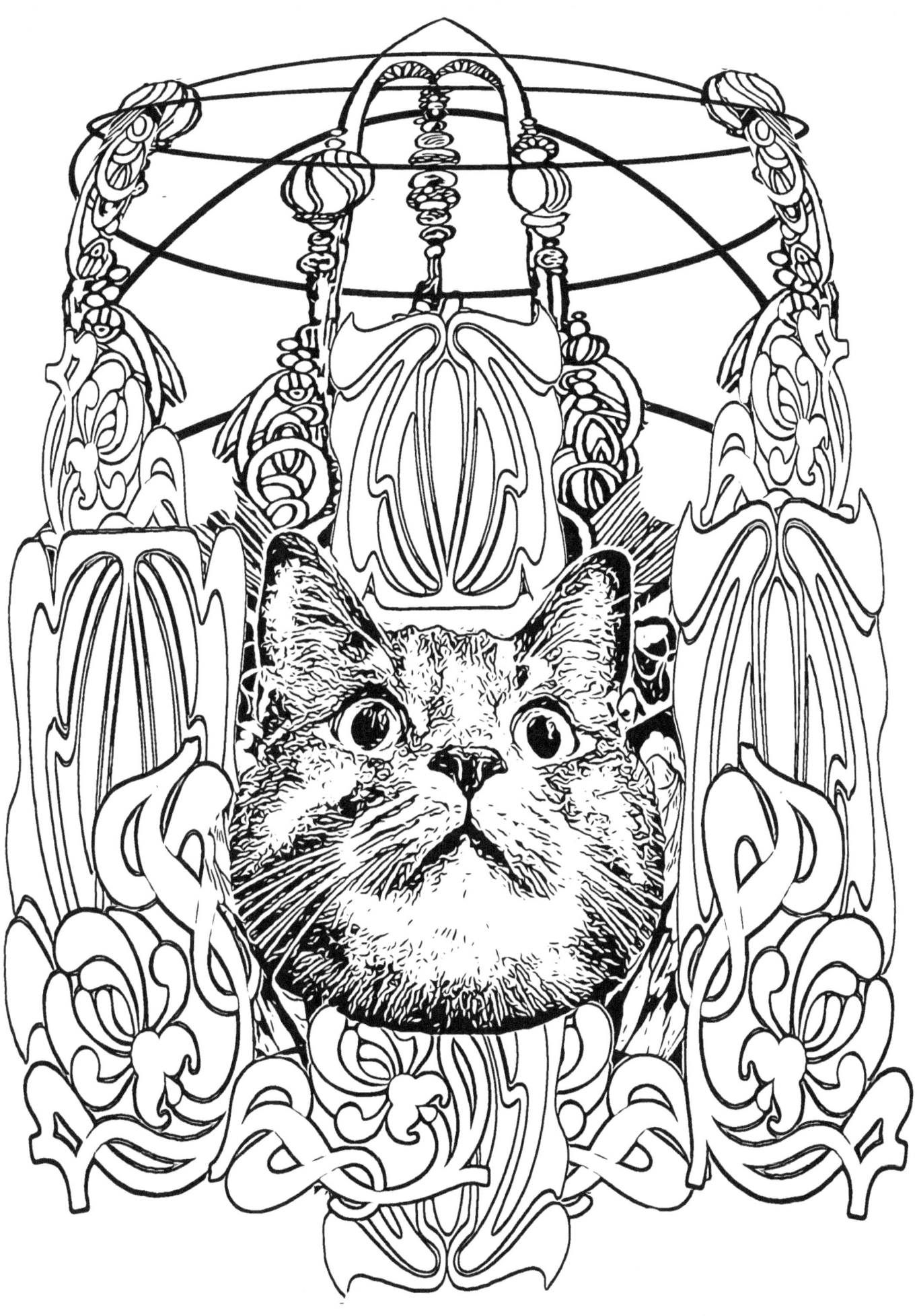

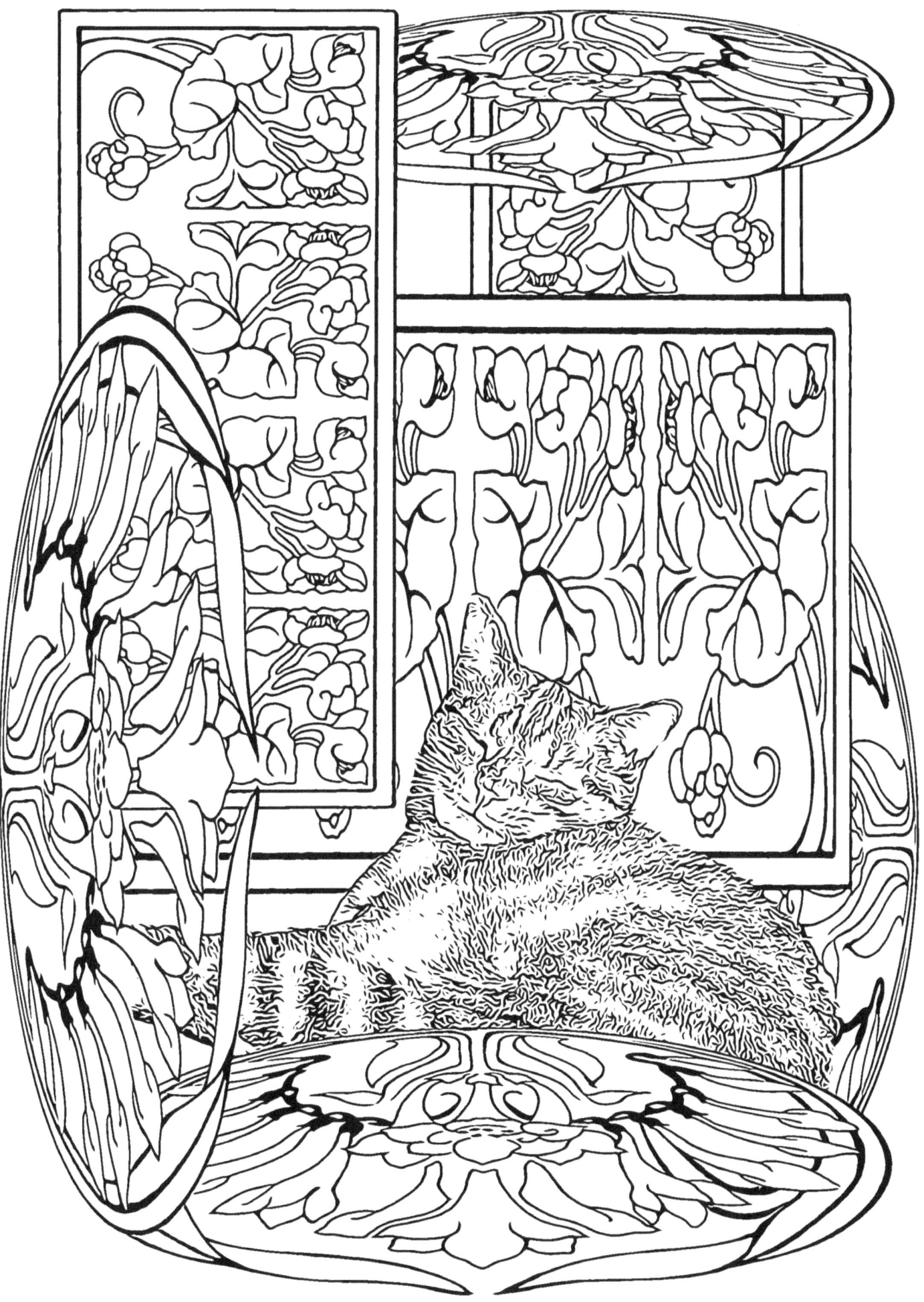

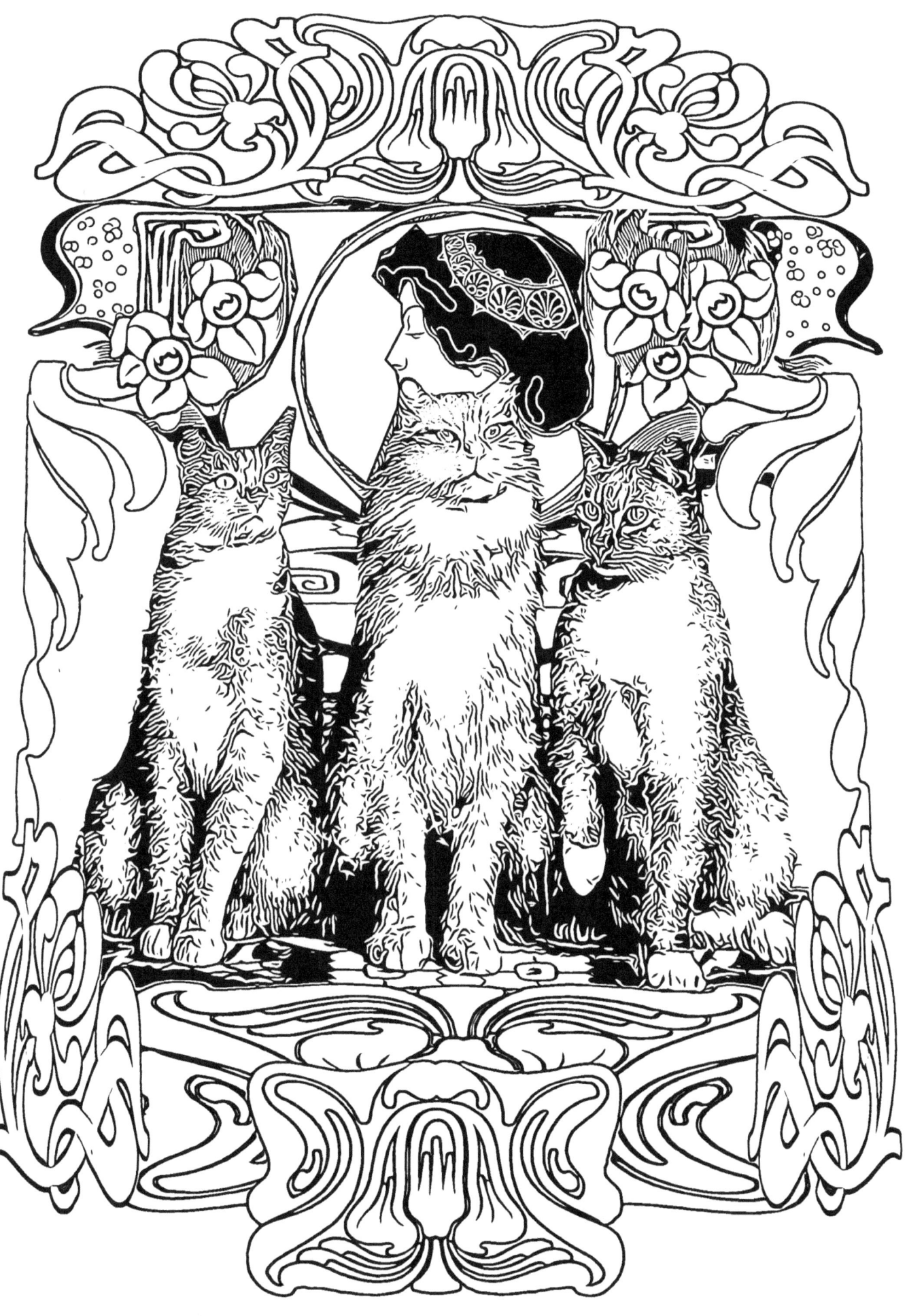

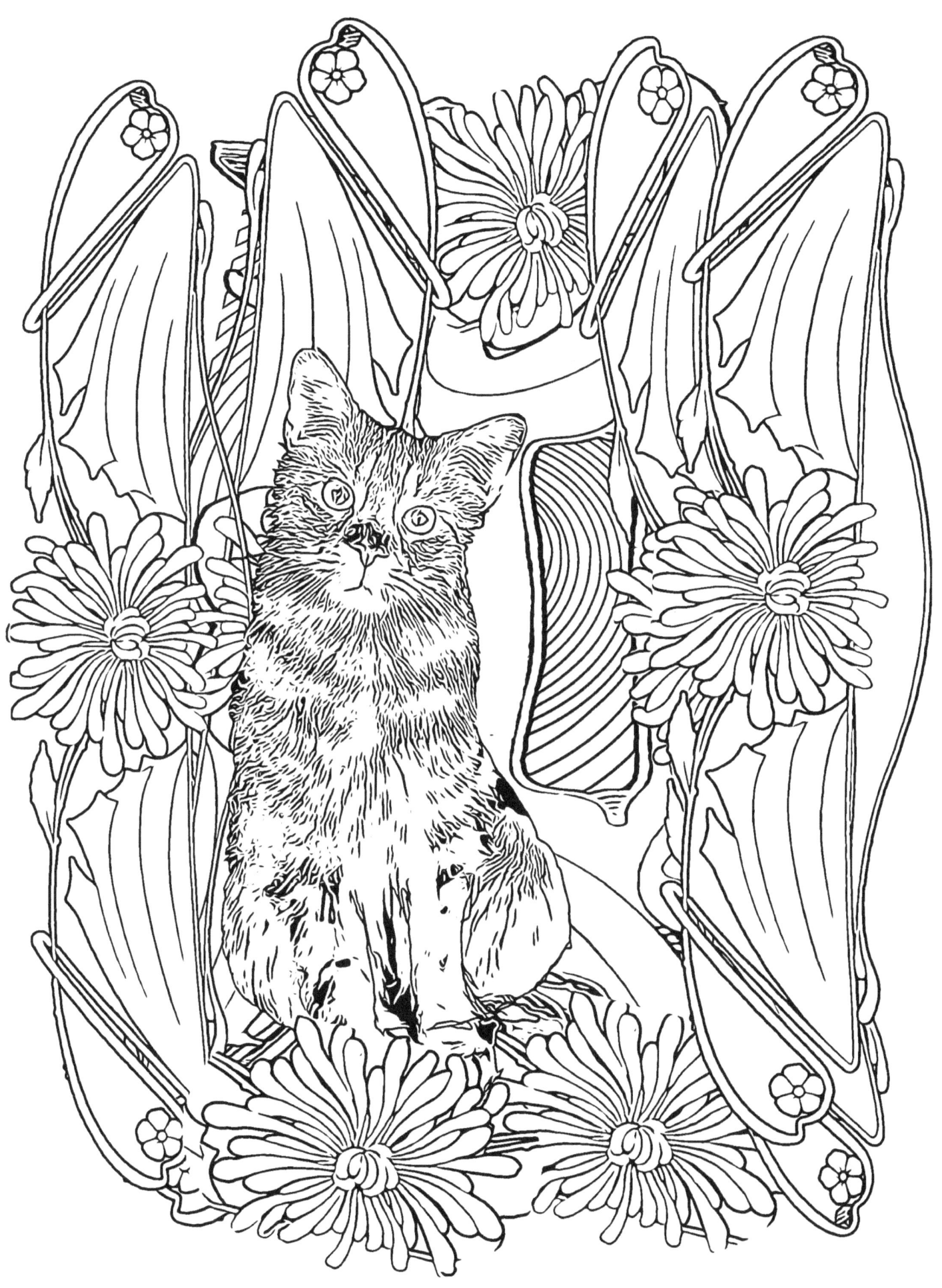

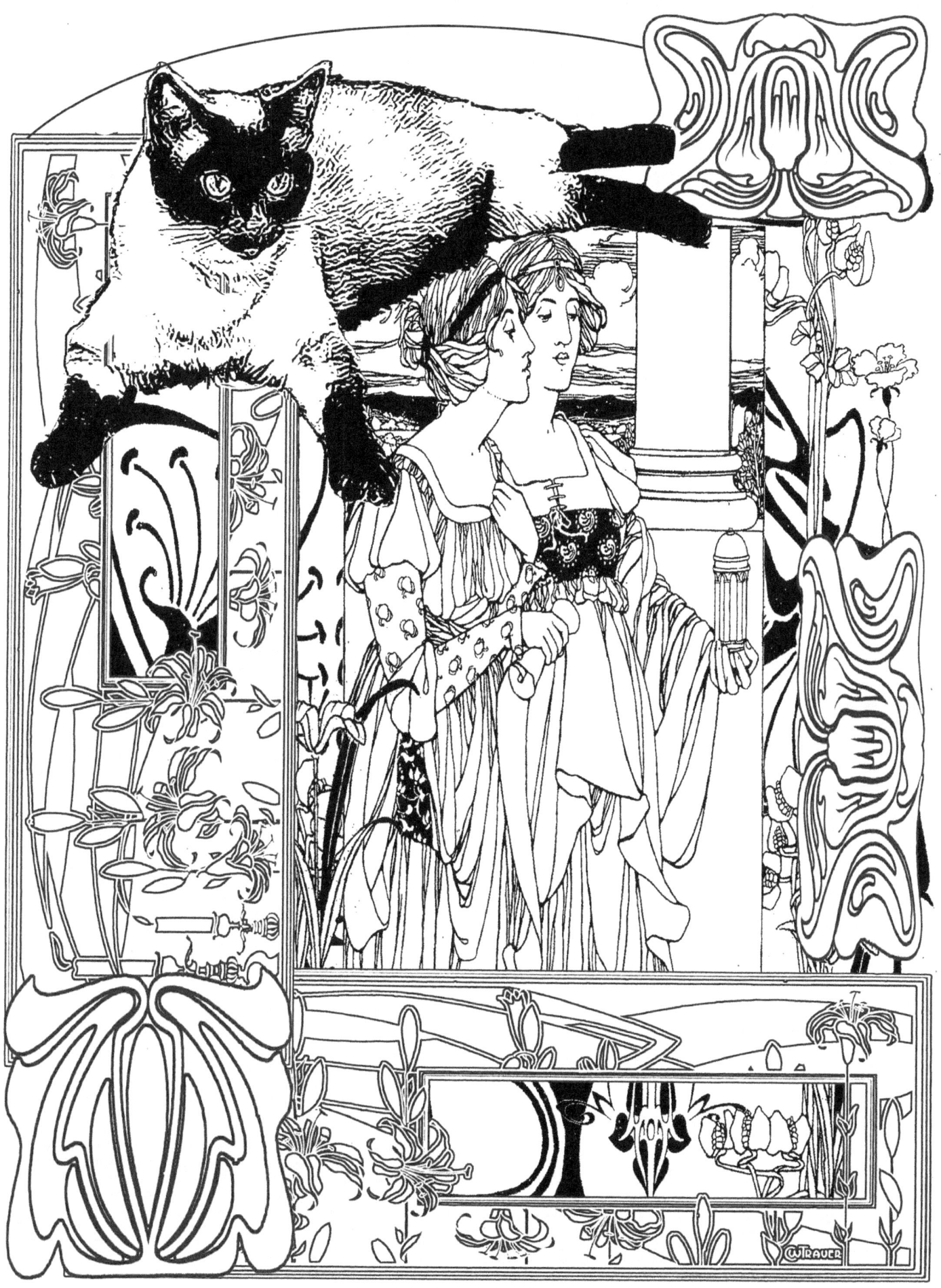

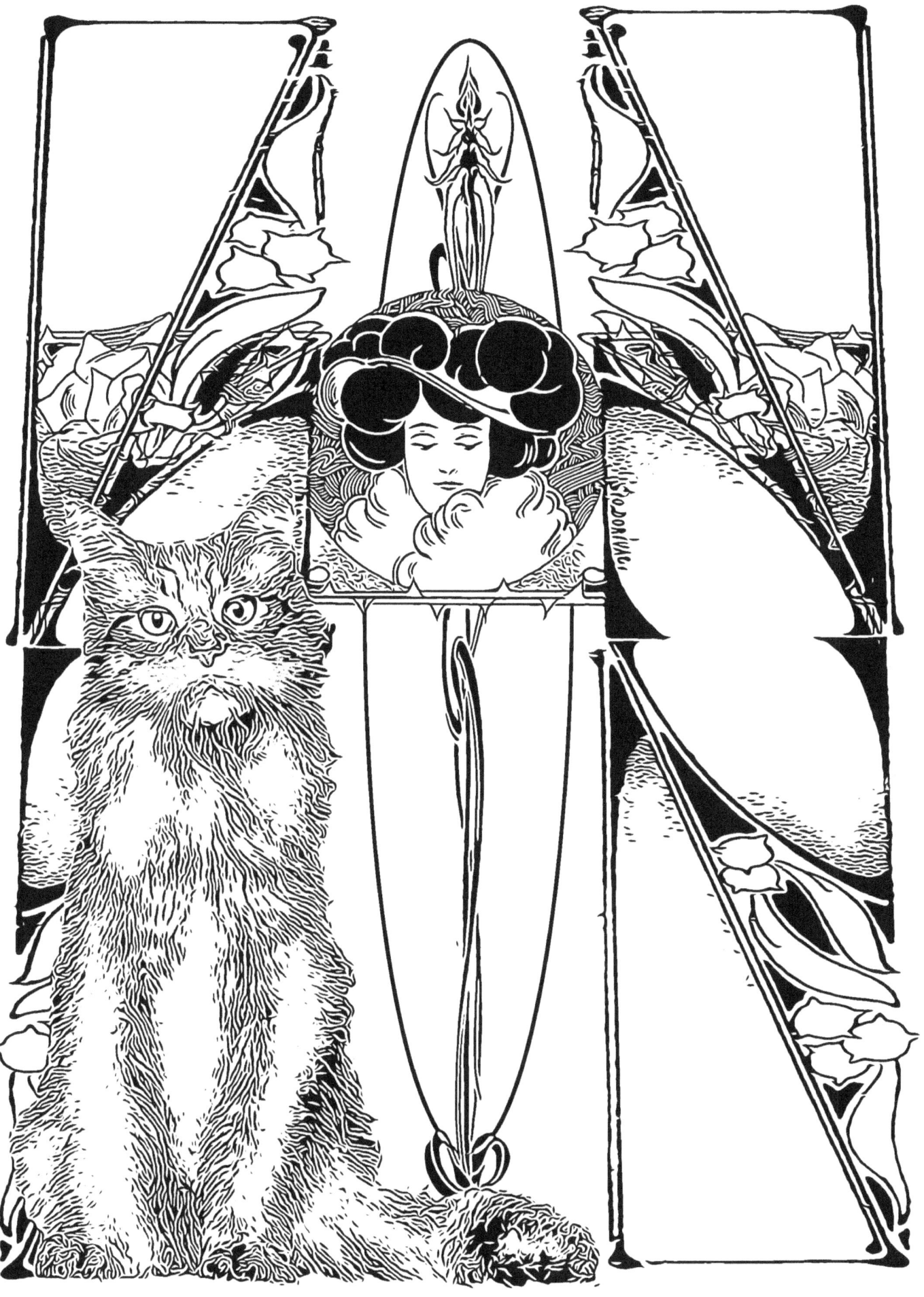

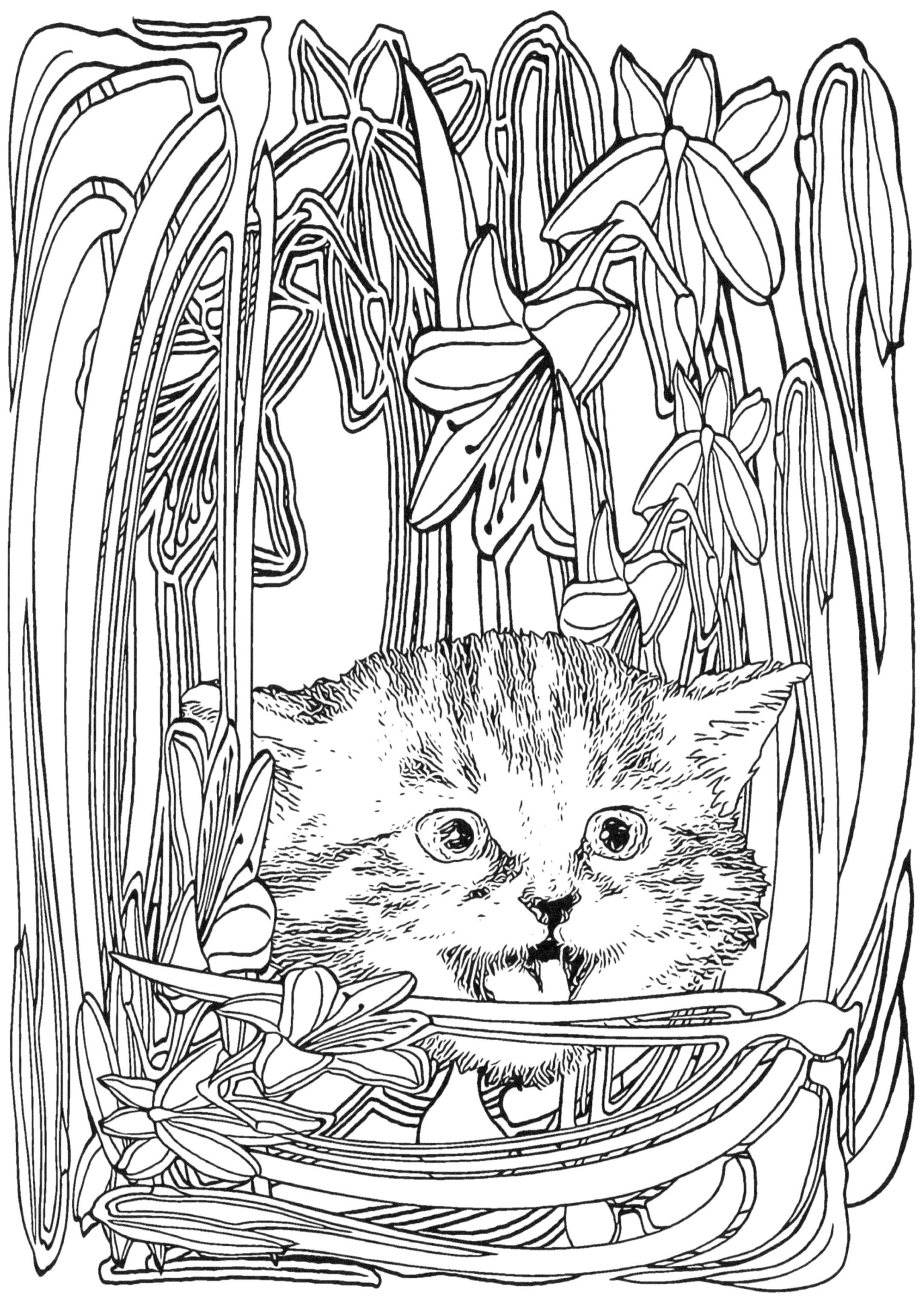

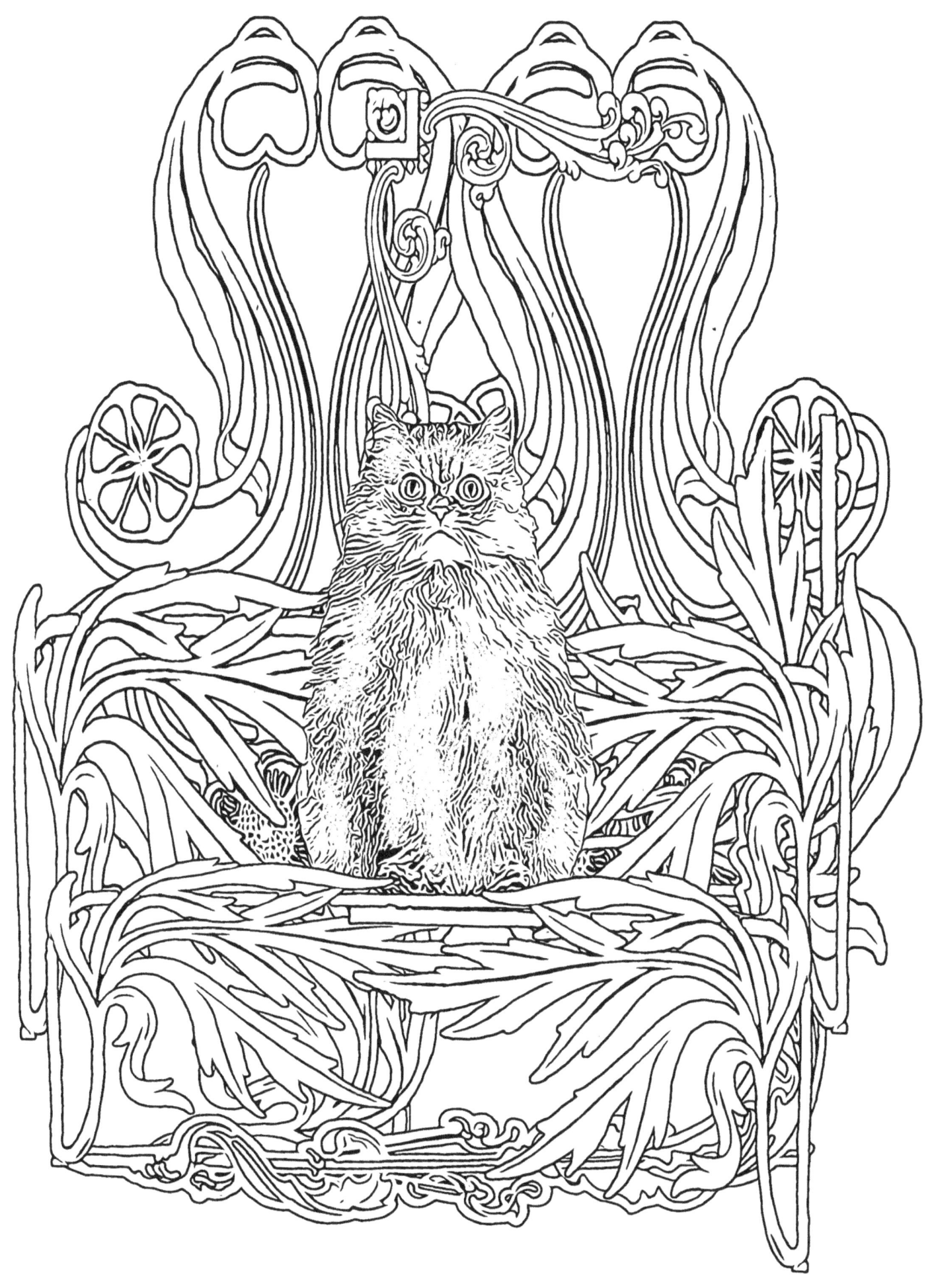

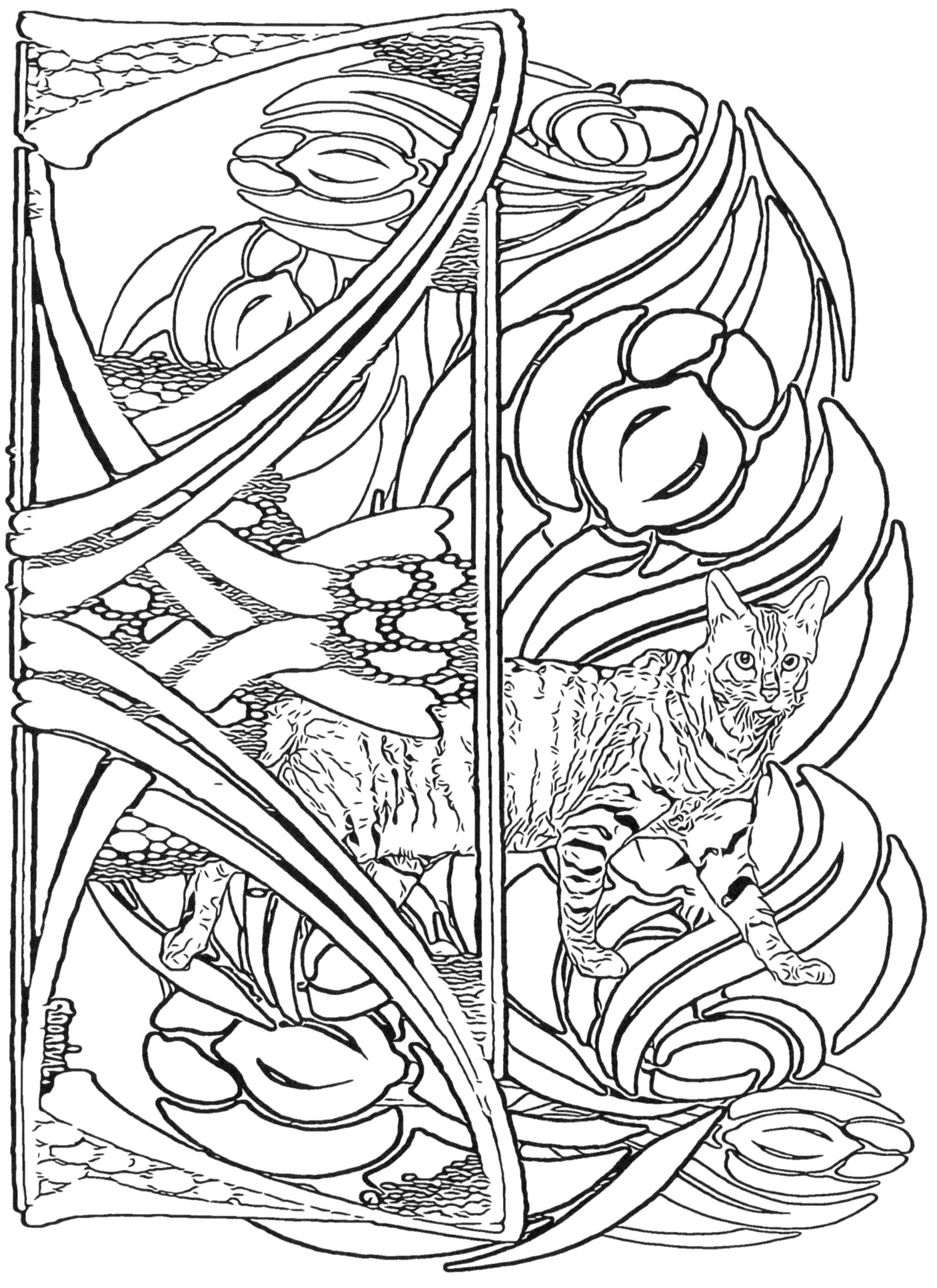

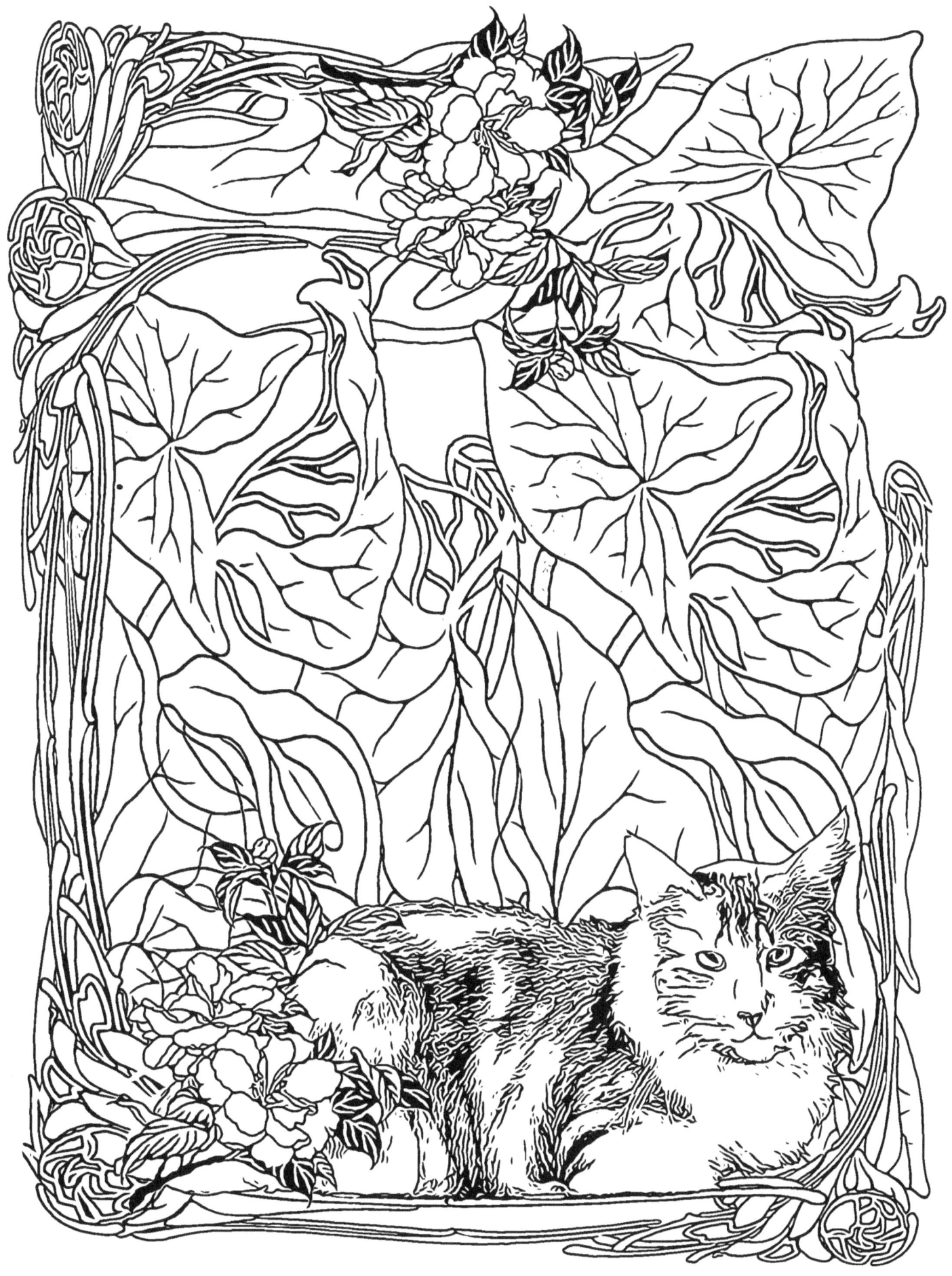

www.ingramcontent.com/pod-product-compliance
Lightning Source LLC
Chambersburg PA
CBHW080718190526
45169CB00006B/2425